IMAGES
of America

THE GREAT
FIRES OF LYNN

On the cover: The walls of the Walter Dyer Leather building at 244 Broad Street come crashing down during the height of the 1981 conflagration. (Courtesy Lynn Museum Collection.)

IMAGES
of America

THE GREAT
FIRES OF LYNN

Bill Conway and Diane Shephard
for the Lynn Museum and Historical Society

ARCADIA
PUBLISHING

Copyright © 2006 by the Lynn Museum and Historical Society
ISBN 0-7385-4553-8

Published by Arcadia Publishing
Charleston SC, Chicago IL, Portsmouth NH, San Francisco CA

Printed in the United States of America

Library of Congress Catalog Card Number: 2006924311

For all general information contact Arcadia Publishing at:
Telephone 843-853-2070
Fax 843-853-0044
E-mail sales@arcadiapublishing.com
For customer service and orders:
Toll-Free 1-888-313-2665

Visit us on the Internet at http://www.arcadiapublishing.com

This book is respectfully dedicated to the brave men and women of the Lynn Fire Department, past, present, and future.

CONTENTS

Acknowledgments 6

Foreword 7

Introduction 9

1. Early Lynn Fires and Firefighting 11

2. The Great Fire of 1889 19

3. Between the Great Fires 41

4. The Conflagration of 1981 87

5. Aftermath 123

ACKNOWLEDGMENTS

Many now-anonymous photographers, both amateur and professional, contributed to the Lynn Museum and Historical Society's collection of images from the early fires and the First Great Lynn Fire.

For the many images of 20th-century fires, including the 1981 conflagration, the museum is particularly grateful to board member Joe Scanlon, the son and grandson of Lynn Fire Department chiefs. The photographs and artifacts he has donated are an extremely important and generous addition to the museum's collection.

The museum is extremely grateful for the participation of former deputy fire chief (and former Lynn Museum president) Bill Conway in this project. Bill's experience and his insights into many of the events depicted here, particularly the conflagration of 1981, have been invaluable.

Many other photographers, particularly Walter Hoey and Bill Noonan, have made important contributions to the museum's collections for which we are very grateful. Volunteers Al Weber and Peggy Dee have consistently given cheerful and thorough help whenever needed.

Thanks also to the board of directors of the Lynn Museum and Historical Society for their continued support and enthusiasm as the museum moves ahead. Also thanks to director Connie Colom for her support—and patience—as this project developed and to the staff of the museum, Jane Bowers, Cathy Mangino, Georgiann Burdette, and Ann Jean Flaxer, for their willingness to help wherever and whenever needed and for much-needed comic relief.

FOREWORD

On the Saturday morning of November 28, 1981, the city of Lynn, Massachusetts, was devastated by a large fire in the heart of the old shoe manufacturing center of the city. This fire became known as the "Second Great Lynn Fire." The "First Great Lynn Fire" was 92 years earlier, almost to the day, on November 26, 1889.

The 1981 fire originated in an eight-story, brick, and wood-joist, vacant shoe factory located in the center of a group of loft buildings of like size and construction. The building of origin was being razed at the time of the fire. At 2:25 a.m. on the Saturday morning of Thanksgiving weekend, fire was noticed in the rear of the Hutchinson Wharf Building located at 264–266 Broad Street. The building was 60 feet wide and 300 feet long before the rear 35 feet were removed during demolition. This inferno burned for 15 hours and 20 minutes before the chief of the fire department declared the fire under control. During this time, 18 industrial buildings had been totally destroyed, 2 others were heavily damaged, and 6 other structures sustained serious damage. Over 700 firefighters with more than 125 pieces of fire apparatus from 80 communities were needed to bring this fire under control.

As the 25th anniversary of the conflagration approaches, this book looks back at this and other fires that have changed the face of the city.

—Bill Conway
Former Deputy Fire Chief
Lynn Fire Department

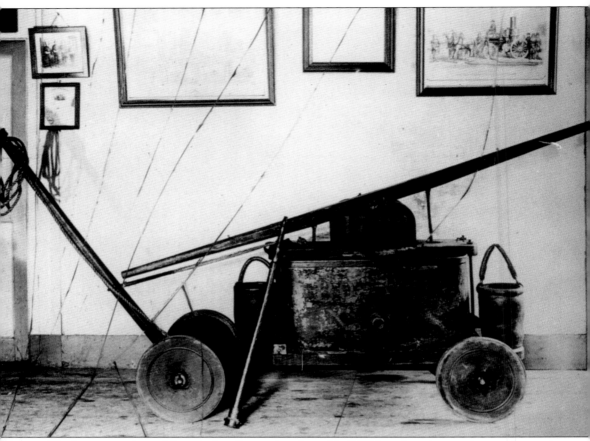

No image survives of Lynn's first fire engine, but this 1792 hand engine at the statehouse in Boston is probably of a similar type.

INTRODUCTION

Few things so clearly demonstrate the tenuousness of man's mastery of nature as fire. Perhaps this is why it has inspired both dread and fascination in equal measure throughout human history. A raging fire compels our attention with its awesome power, while at the same time it arouses our fear with its destructiveness. Our admiration for the skills and courage of firefighters is matched by our anxiety for their safety. These factors together make for a spectacle that demands our attention, often in spite of ourselves.

Although Lynn, Massachusetts, was founded in 1629, in many ways it has more in common with purpose-built cities such as Lowell and Lawrence than other Colonial-era towns like Salem and Marblehead. With a harbor too shallow for large ocean-going vessels, Lynn turned to industry rather than trade for its livelihood. While in its earliest years it was subject to the same fire hazards that tended to plague other rural areas—wooden barns stacked with flammable hay, slow communication that allowed fires to destroy buildings before effective aid could arrive—by the 19th century its burgeoning industrial power made it prey to a wholly different and far more powerful type of danger. Lynn's major industry was shoe manufacturing, a process that involved the use of many highly flammable chemicals. In addition, earlier wooden buildings from the prior centuries were crowded close against the factories, making for a highly charged situation. This fact had long been recognized by city officials, and the annual city reports address the inadequacy of the city's preparation from almost the moment of Lynn's incorporation as a city. As early as 1859, the *Weekly Reporter* wrote anxiously that "we have virtually no protection against the ravages of a conflagration, nor are we likely to have any until the necessity is made apparent by the burning of a large tract, and the destruction of several thousand dollars worth of property."

That dire prediction would come all too true in the following decade when the Lyceum Hall and much of Market Street was destroyed on a Christmas night blaze in 1868. This was the largest and most destructive fire in the city's history up to that time, and it shared many characteristics—and causes—with the other significant fires of the future.

As with so many other aspects of Lynn's history, its fire history is tied inexorably with the varying fortunes of the shoe industry. In 1868, thanks to the widespread introduction of machinery, the industry was on the verge of exploding to unprecedented levels of productivity, taking the city to new highs of population. The 1868 fire, devastating as it was, demonstrated the city's unpreparedness to deal with the demands true, modern industrialization would bring. At the same time, more symbolically, it wiped out a building that had once been at the social, political, and cultural center of the town, but had increasingly seemed quaint and inadequate.

Similarly the fire of 1889 had its roots in the growing pains of the shoe industry. In the 20-odd years since the Lyceum fire, shoe manufacturing output had increased enormously but the physical resources had not kept up. Lynn was not unique in this aspect; many other cities in Essex County—Salem, Haverhill, and Marblehead—suffered their own "great fires" during this period. The strain placed on outdated buildings and overcrowded conditions eventually and inevitably were released in a conflagration that destroyed virtually the entire industrial center.

By the time of the 1981 conflagration, the shoe industry had virtually disappeared from Lynn, leaving the hulking, empty shells of shoe factories to be fodder for the flames. Even the worst of Lynn's residential fires can trace their sources indirectly to the shoe industry. Rooming houses such as the Essex Castles and Melvin Hall were typical of the living quarters built near the beginning of the 20th century for the ever-increasing number of workers flocking to the factories. As the industry declined, so too did the conditions at the rooming houses, resulting in horrific loss of life when fire struck.

Lynn's fire history is a long and complex, sometimes tragic, one. Full justice to the story of the fire department, the evolution of firefighting, and the stories behind many of the images reproduced here cannot be accomplished in such a small volume, and it is not attempted. With the exception of the two great fires of 1889 and 1981, the choice of which events to represent here has often depended on what images were available; not every significant fire in Lynn's past has been well documented. The fire at Paul Revere Hall on Chestnut Street, in which a firefighter lost his life, for example, is not mentioned in the text because no adequate image remains. For this and other omissions, the authors apologize and ask that any reader who possesses important images allow these to be copied for the museum's collection so that the bravery and sufferings of all those that are now anonymous may be represented in the historical record.

One

EARLY LYNN FIRES AND FIREFIGHTING

The fabled bucket brigade was the earliest method for extinguishing flames in Lynn, as elsewhere in Colonial New England. Every able-bodied citizen in the area assembled, buckets in hand, passing full buckets along a human chain from the nearest water source to the fire, and returning empties to be refilled. The names painted on each bucket assured that everyone got their own bucket back at the end of each alarm and allowed householders to demonstrate compliance with fire regulations.

As may be imagined, the bucket brigade was woefully inefficient and the early chronicles of Lynn demonstrate that few buildings survived a brush with fire. As firefighting equipment improved and hand-pump engines came into use, the brigade still retained some usefulness as a means of keeping the engines filled with water. The buckets from the Lynn museum's collection, above and on page 11, date from this later period.

This rather inauspicious structure was the home of Lynn's first hand engine, it was purchased by the town in 1796 and given a place of honor on the common. The quiet, rural nature of the town at the time is demonstrated by the fact that the engine stood idle for three years before being called into service for a fire at Micajah Newhall's barn. The fact that the barn, only on the opposite side of the common, was a total loss is a testimony more to the still very imperfect equipment rather than the zeal of the firefighters who had kept themselves at the ready throughout the lengthy stretch of down time.

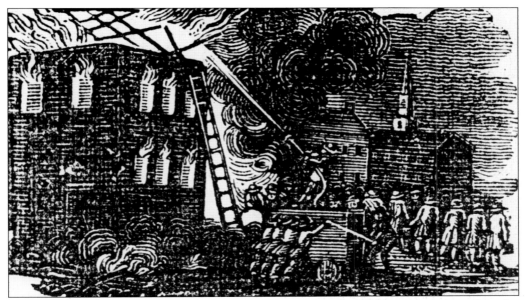

Until the official organization of the Lynn Fire Department in 1836, various independent fire clubs provided such protection as was possible. The above woodcut is from the constitution of Engine and Hose Company No. 5 at Woodend. Even after the companies were consolidated into a single department, they retained a good deal of independence.

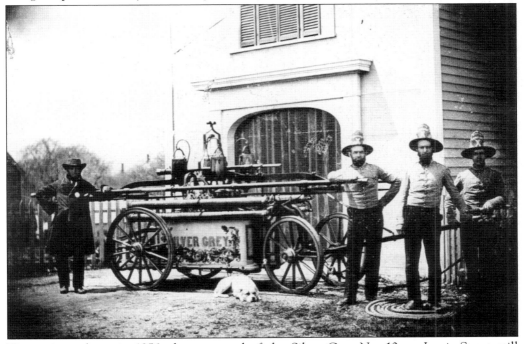

Twenty years later, in 1856, the personnel of the Silver Grey No. 10 on Lewis Street still identified themselves primarily with their company rather than the department. The fact that they remained volunteer workers, each company allowed $20 per year for "socials, etc.," may have contributed to that feeling.

FIVE HUNDRED DOLLAR REWARD!

MAYOR'S OFFICE,

CITY OF LYNN, June 22, 18

By authority of the City Council, I hereby off
a Reward of FIVE HUNDRED DOLLAR
for such information as shall lead to the detecti
and conviction of the person or persons who s
fire to the **CATHOLIC CHURCH**, in this city;
the building adjacent thereto, on the evening
the **28th of May last.**

In an age when house and barn fires were usually the most serious occasions, the 1859 arson
burning of the only Catholic church in Lynn caused widespread outrage in the city government
and newspapers. Anti-Catholicism was rampant, however, and no doubt many secretly approved;
no one was ever charged with the crime.

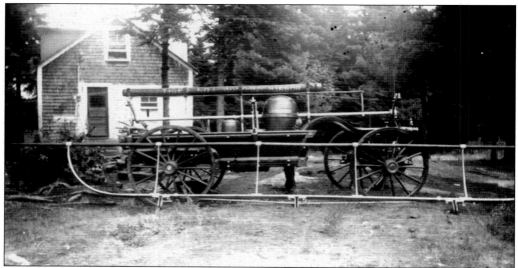

The last hand fire engine purchased by the city was the *Tiger No. 4* for the Glenmere firehouse.
After its use was discontinued in Lynn, it did service in Warren, Maine, eventually landing
in the hands of a private collector until it was purchased by the Lynn Museum and Historical
Society in the 1990s.

On May 7, 1865, the elegant home of the recently deceased historian William Prescott on Ocean Street was entirely burnt with all its contents in what was deemed to be an incendiary fire. The city could take some comfort, however, in the performance of their new steam fire engines, which were able to pump water from Goldfish Pond and contain the damage to that one structure.

The Lyceum Hall, which stood at the corner of Market and Summer Streets, was built in 1841 and hosted a variety of lectures, operas, and other popular entertainments in its day. On Christmas night 1868, it was the site of the most devastating fire the city had seen to that point.

The lengthy exposure time required by 1860s photography meant that no photographs could be taken of rapidly moving objects. This painting, by an unknown artist, is one of the only images available of the Lyceum Hall fire. At least $300,000 worth of damage—an enormous sum for the day—was sustained, and Lyceum Hall and several other buildings were totally destroyed.

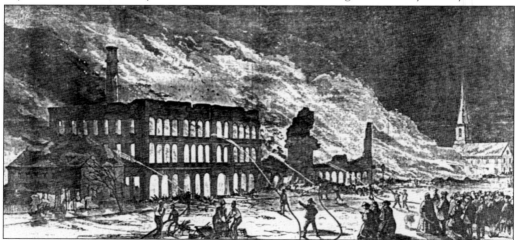

Chief engineer Sylvester Breed suffered the loss of one of his steamer engines in the first moments of the fire and continually struggled with the water supply, thus frustrating the best efforts of his crews. In his year-end report to the city government he rather pointedly lamented that "the failure rests on the want of water . . . and shows the necessity of a careful consideration of our reports, from year to year, that we may be provided with such appliances as may be deemed advisable for the safety of our city." National newspaper *Frank Leslie's Illustrated News* reported on the fire with the above illustration attached.

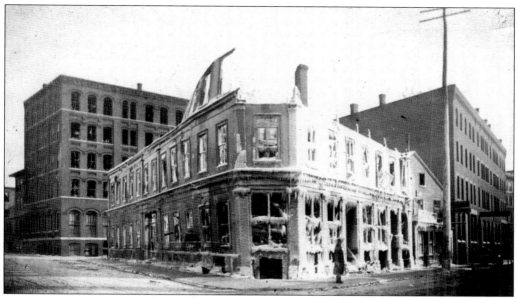

Charles A. Coffin, soon to be a major figure in the General Electric Company, also owned a shoe factory on Central Avenue. On February 17, 1885, a fire of unknown origin totally destroyed the factory and caused considerable damage to surrounding structures.

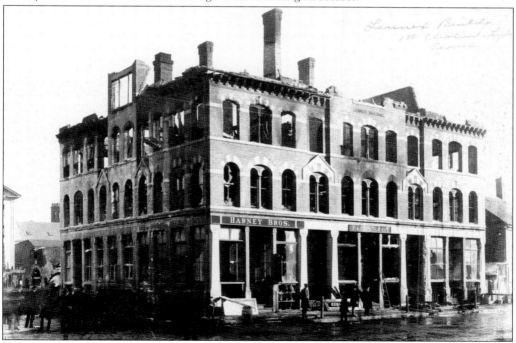

As Lynn's industrial center grew, so too did the dangers. Shoe and leather factories, which dominated the city's industry, were highly susceptible to flames due to the variety of highly flammable chemicals in use. The Patrick Lennox Company was a leading leather firm, on the corner of Market Street and Harrison Court, when it burned on December 22, 1888, with a loss of $104,000.

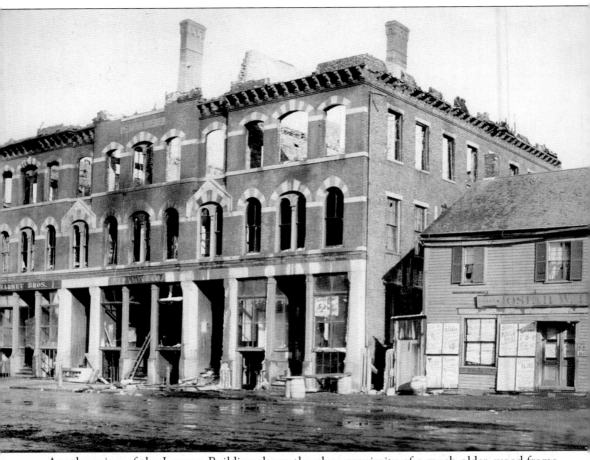

Another view of the Lennox Building shows the close proximity of a much older, wood-frame building. This was a consistent pattern throughout the factory district and one that would have devastating consequences in the very near future.

Two

THE GREAT FIRE OF 1889

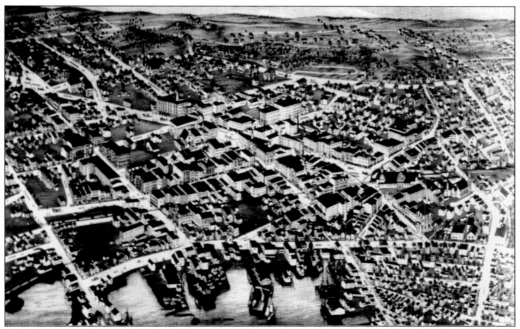

By 1889, Lynn was at a new height of its industrial prosperity. One of the world's leading producers of women's shoes and a pioneer in electric lighting, the city was a magnet for workers from around New England and the globe.

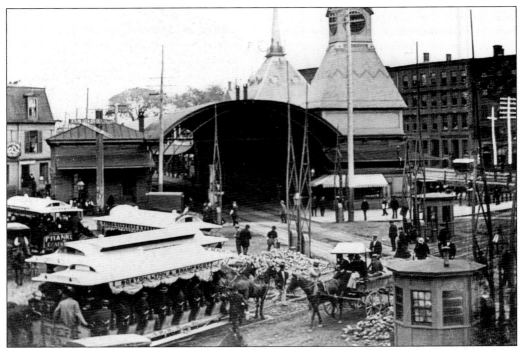

Central Square was a hub of activity each day as pedestrians, horse cars, and locomotives jostled each other in the streets every morning, evening, and lunch hour. Above is the Boston and Maine depot built in 1872.

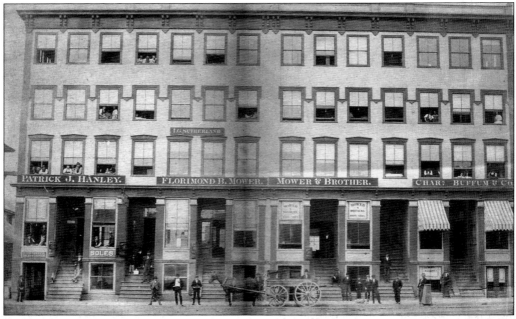

At 11:45 a.m., November 26, 1889, a small stove was accidentally upset in the Mower Building, on the corner of Blake and Almont Streets, igniting the oil-soaked floors of the four-story wooden structure. By that evening, 31 acres of Lynn's industrial center lay in ruins.

Workers from the hundreds of shoe and leather factories in the downtown swarmed the streets as the fire spread and buildings were evacuated. Many returned with cameras in hand to record the devastation. This photograph of lower Union Street is one of many surviving amateur images, taken with an early Kodak camera. The circular frame of so many of the amateur photographs was a characteristic of the recently invented Kodak camera. The camera was loaded with 100 exposures and required relatively little skill to operate. Once full, the entire camera was returned to the company for developing.

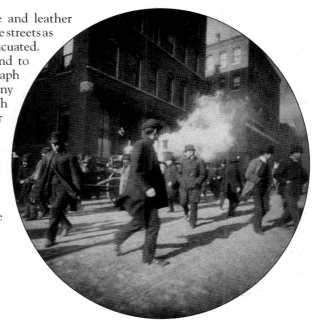

Within moments, the flames had spread through the adjacent buildings. All the buildings here on the east side of Munroe Street were soon enveloped as well and totally lost.

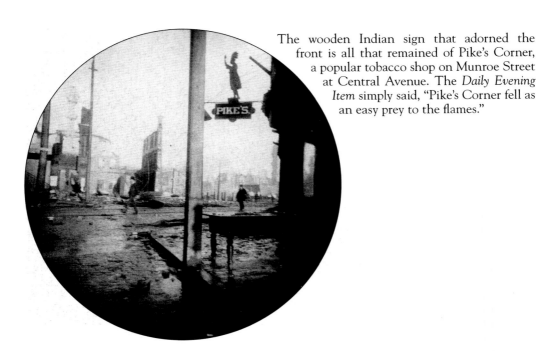

The wooden Indian sign that adorned the front is all that remained of Pike's Corner, a popular tobacco shop on Munroe Street at Central Avenue. The *Daily Evening Item* simply said, "Pike's Corner fell as an easy prey to the flames."

Washington Street and Railroad Avenue were next in the path, scarcely an hour after the first alarm was given. The Lynn Die Company on the right was likewise lost.

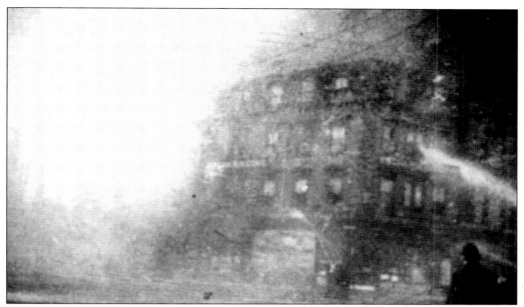

Mere moments after the above photograph was taken, firefighters were battling flames at the Brick Bergengren's Block at the corner of Union Street and Central Square. The *Lynn Daily Evening Item* reported, "The rapidity with which the flames spread and the slight resistance offered by the materials with which the substantial buildings were constructed was a source of general wonder. Brick, iron and granite burned almost as quickly as wood."

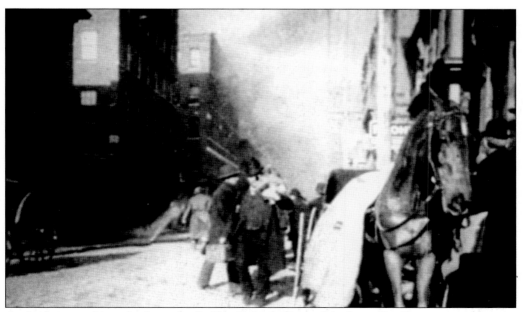

As the fire spread, seemingly unchecked by the best efforts of the Lynn Fire Department, business owners and occupants of buildings in harm's way attempted to remove as many valuables as possible before the inevitable struck. By 1:30 p.m. the horse carts on Union Street were mere moments ahead of the flames.

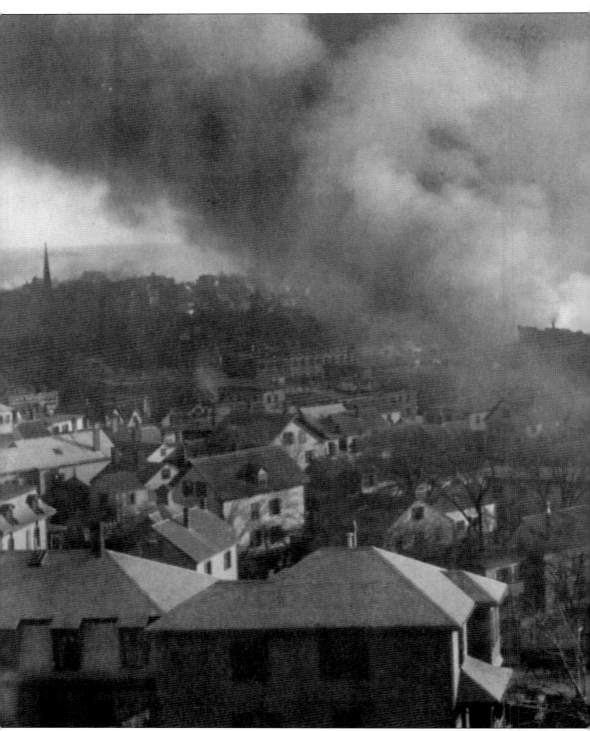

A view from High Rock at the height of the fire shows the steady path of destruction enveloping downtown Lynn. The coal wharves along the waterfront would continue to burn and spew

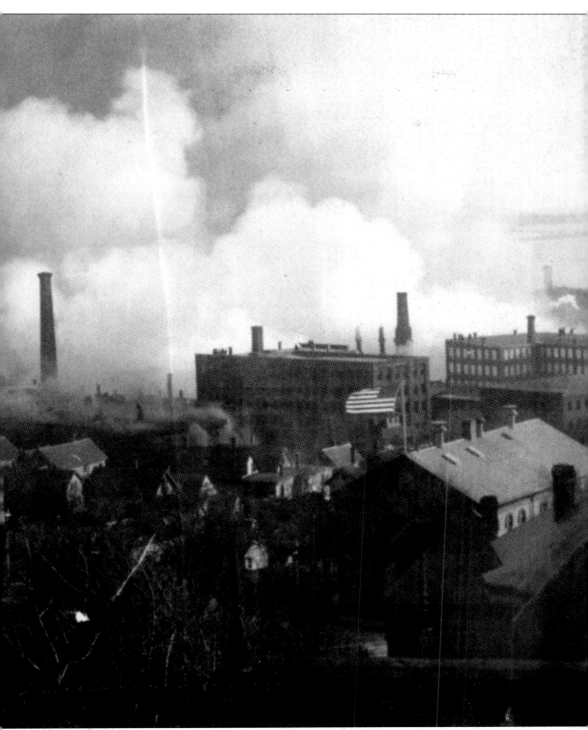

smoke for days after the flames had been extinguished elsewhere.

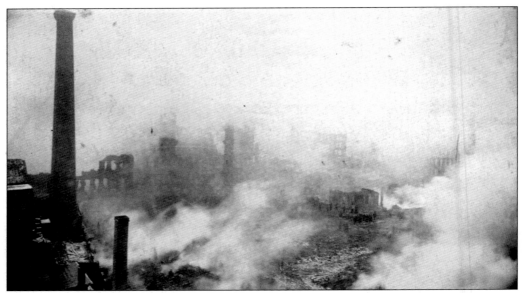

From the outbuildings of the Sawyer and Chase carriage manufactory that backed onto Union Street, the flames burst through to Broad Street, above, and swept past Spring Street to Exchange Street and across to Beach Street and the waterfront.

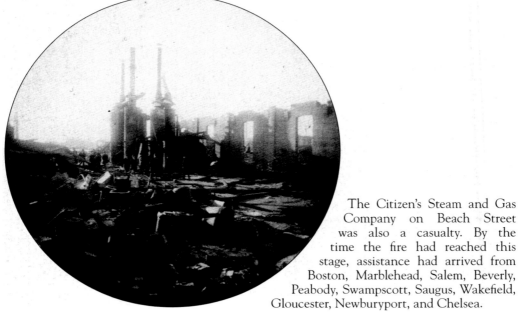

The Citizen's Steam and Gas Company on Beach Street was also a casualty. By the time the fire had reached this stage, assistance had arrived from Boston, Marblehead, Salem, Beverly, Peabody, Swampscott, Saugus, Wakefield, Gloucester, Newburyport, and Chelsea.

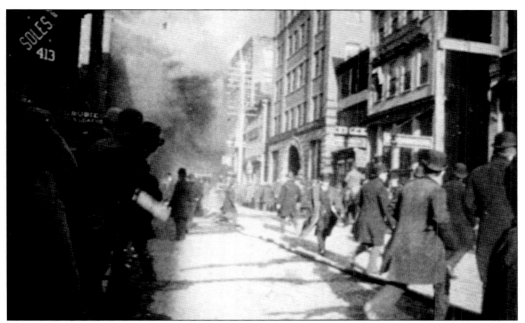

Downtown streets were crowded with onlookers, not all of whom were motivated by curiosity alone. The *Lynn Daily Evening Item* reported that "the fire was no more rapid in its work than were the thieves. The local fraternity was re-enforced by skillful co-operators who arrived from Boston with the relief force early in the afternoon. With every pretence of offering assistance they committed the most daring thefts."

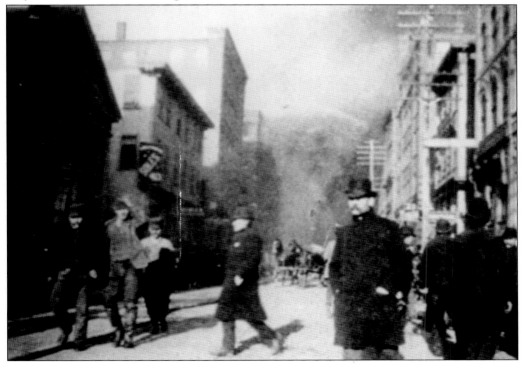

Lynn Laid in Ruins.

Loss Estimated at $5,000,000.

100 SHOE SHOPS BURNED.

The Daily Papers All Go.

162 FAMILIES ARE HOMELESS.

ITEM EXTRA

THREE O'CLOCK.

IN RUINS.

Terrible Visitation to Our City.

Swept by Acres of Flame.

The Largest Shoe Facto-
ries Burned.

Central Church De-
stroyed.

The headlines of the *Lynn Daily Evening Item*, left, and the *Lynn Daily Press* on the morning of November 27 are all the more frightening for the terse manner in which they tick off the almost unbelievable list of losses the city had endured.

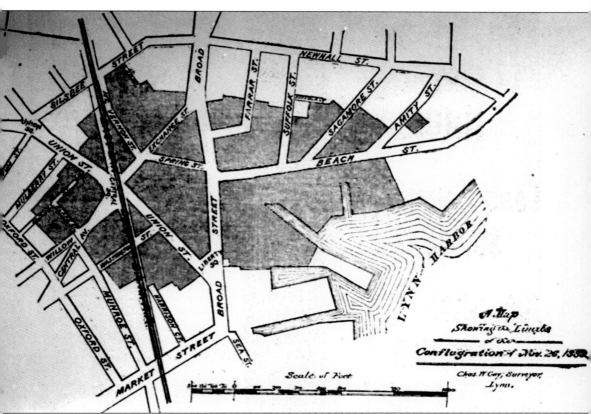

This map by the city engineer shows the full extent of the area destroyed. Two days after the fire the *Lynn Daily Press* counted "42 brick buildings, mostly large manufacturing blocks burned; 112 wooden mercantile and manufacturing buildings and 142 dwellings. The number of families thrown out of homes is 162. . . . Of the three precincts of Ward Four, to which the fire was confined, Precinct 1 lost one-third [of its total valuation]; Precinct 2 one-half; Precinct 3, one-half." Remarkably, however, there was no loss of life.

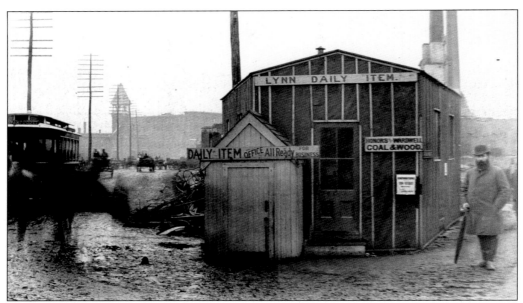

By the morning of November 27, the *Lynn Daily Evening Item* declared itself "ready for business." With its former headquarters a total loss, publisher Horace Hastings "borrowed" this tiny wooden outbuilding then under construction on the Lynn marshes and had it set up in Central Square. A much later newspaper account reported that Hastings eventually "settled liberally with the owner of the building."

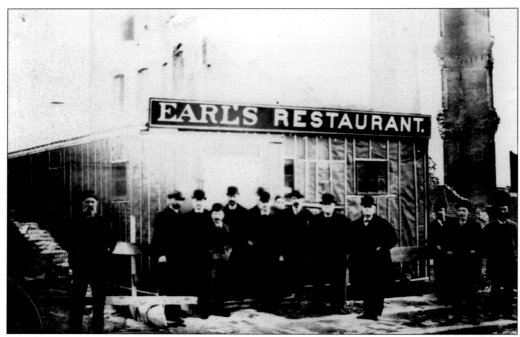

John Earl's restaurant and saloon at Exchange and Union Streets was another business that was back in operation almost immediately with a makeshift replacement building, to the apparent satisfaction of its regular customers.

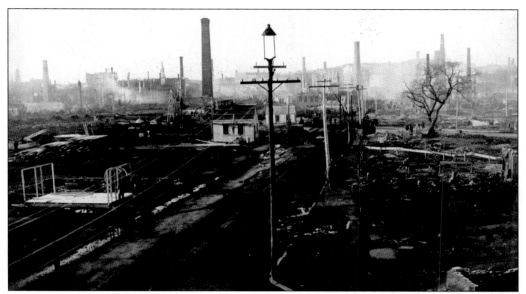

Although the costliest damage occurred to commercial properties, many working-class homes were also lost, particularly in the Sagamore Hill neighborhood. The view here is looking down Beach Street from Sagamore Street. S. N. Breed's lumberyard lies in ruins to the left.

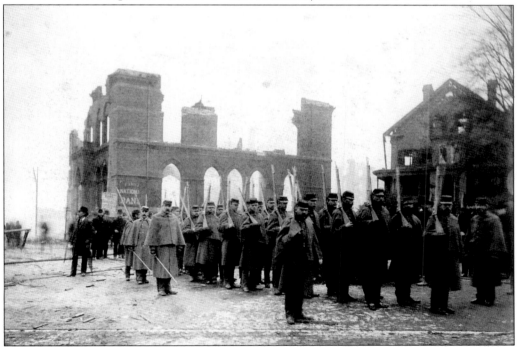

Soldiers from the 8th Massachusetts Volunteer Militia headquartered at the Lynn Armory patrolled the streets as the fire was brought under control and for several days afterward. Behind them are the ruins of the First National Bank that stood at the corner of Broad and Exchange Streets. The house on the right, belonging to a Mrs. Breed, was the last one to fall on the fire's Broad Street front.

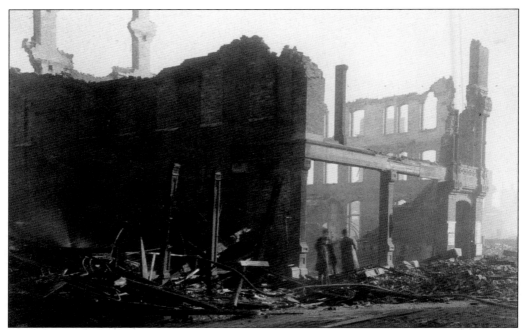

The remains of the brick Mower Block are on the right while the wooden Mower building, where the fire started, is nothing but rubble, clearly showing the danger that the antiquated wooden structures that dotted the industrial area presented.

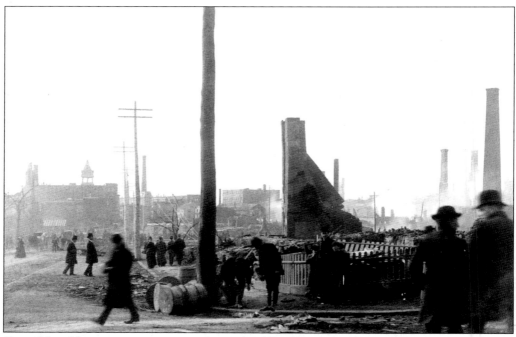

One of the oldest structures to succumb was the Alley House at 183 Broad Street, near Exchange Street. The remaining chimneys, heavy and squat amid the slender smokestacks, are a testament to sturdy Colonial architecture.

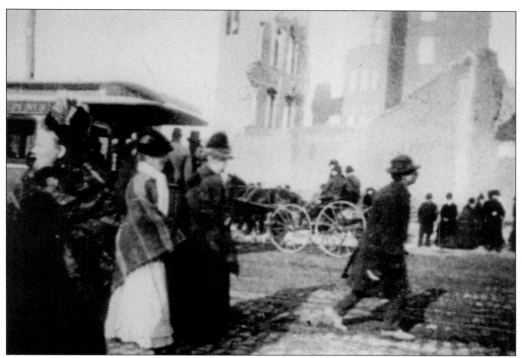

The day following the fire had an odd, almost carnival-like atmosphere as sight-seers from surrounding towns came by all means available to marvel at the devastation. In the photograph below, two men, happily untouched by the events personally it may be assumed, even staged daring climbs up telephone poles for the benefit of the camera.

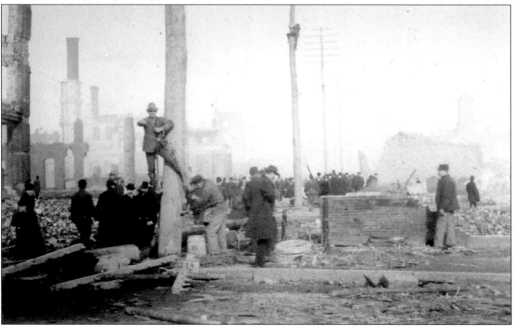

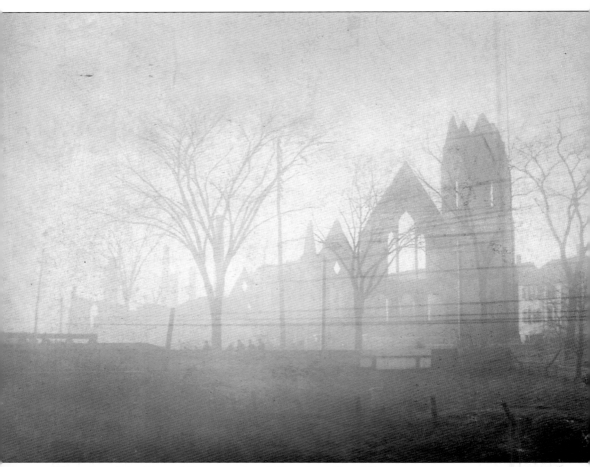

The ruins of the Central Congregational Church on Broad Street are given a hauntingly Gothic appearance by the setting sun and the lingering haze several days after the conflagration.

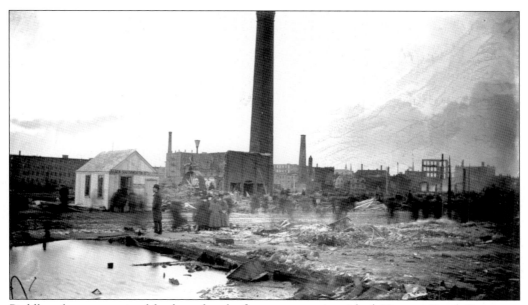

Puddles of water remained for days after the flames were extinguished. Here, on Beach Street, yet another business owner is eager to reassure his customers that he is still available. In this case it is a carpenter, Alden Southworth, whose skills were no doubt in heavy demand in the days and months to come.

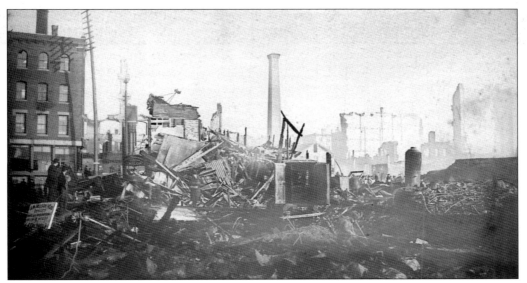

The rubble of the wooden Dickson Building on Willow Street is visible in the center; on the extreme left, in a familiar pattern, a sign for J. M. Nelson and Company, druggists, informs their customers that "all prescriptions were saved and may be refilled at C. A. Caldwell's." Many businesses were able to save records or stock before losing their buildings.

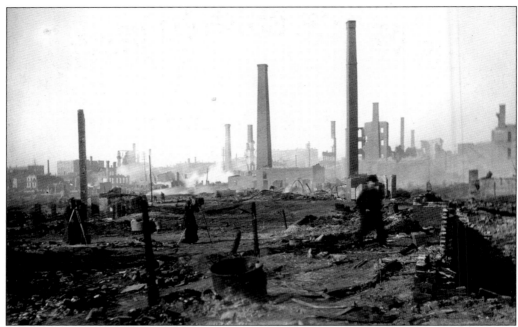

The ruins of the fire proved to be as popular a theme for amateur photographers as the fire itself. Indeed, as the dust settled in the days that followed, the stark, almost serene quality was compelling.

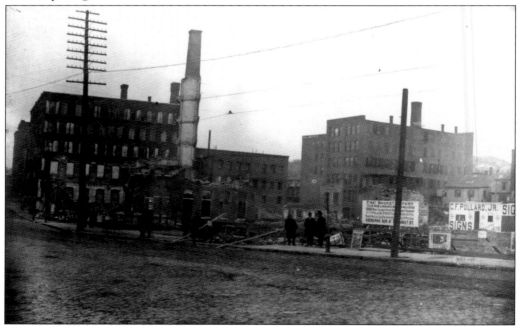

Within a week, more and more businesses were attempting to make the best of a bad situation. Here—under the rather alarming but certainly attention-getting heading of "Fire! Smoke!! Water!!!"—Wellman Osborne advertised $10,000 worth of (slightly soiled) boots, shoes, and rubbers at fire sale prices.

VIEWS OF THE BURNED DISTRICT

LYNN, MASS.

BEFORE AND AFTER THE FIRE.

Nov. 26, 1889.

Enterprising newsstand operator George Merrill was quick to feed the seemingly bottomless public appetite for fire scenes with this hastily printed pamphlet *Views of the Burned District* featuring low-quality images and not much in the way of information.

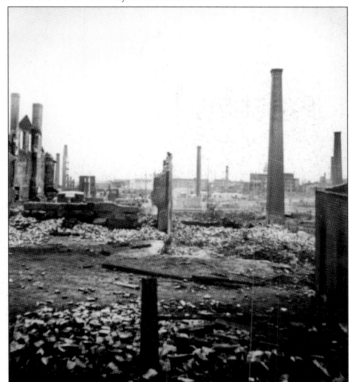

The ruins were cleared away rather quickly since they presented a serious hazard. Before the worst had been cleared, however, an unknown photographer framed the desolation in one of the windows from the burned-out Congregational church.

With the city's main industry all but destroyed, at least temporarily, unemployment was widespread. The Lynn Relief Committee was organized immediately, and one of the first tasks, as reported in the *Lynn Daily Press*, was "to secure to Lynn workmen and mechanics the preference for doing the vast amount of work to be done in clearing up the ruins of the fire and building new buildings." The form above was designed to ensure that goal.

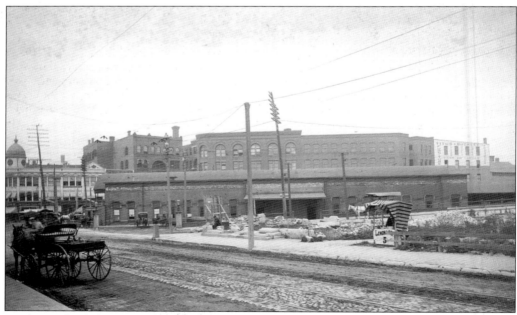

As the work of clearing and reconstruction began, ancillary businesses arrived to take care of the needs of the workforce. An early arrival was this lemonade stand near the ruins of the old railroad depot.

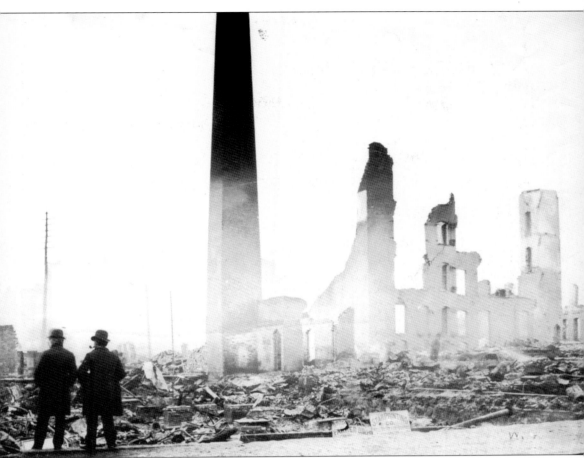

A total of 384 buildings were lost and an excess of $5 million in damage was incurred in what would be known for generations as the Great Lynn Fire. For most Lynn residents who lived through it, it became a kind of a touchstone whereby time was measured; all important events would be described for years to come as "before the big fire" or "after the big fire." It was habit that future generations of Lynners would be forced to adopt as well.

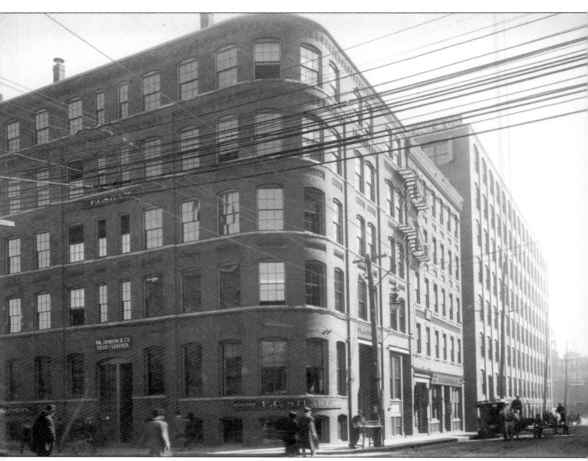

Above is the corner of Washington and Union Streets rebuilt. Ironically—and this was quickly recognized at the time—the first great fire proved to be an enormous boon to the city's economy in the long run. The wholesale destruction of the industrial center had the effect of providing a clean slate for rebuilding. Smaller, antiquated factories were replaced with large, state-of-the-art facilities, and Lynn's shoe industry was to become even more dominant than ever. In fact, the 30 years following the 1889 blaze were the most prosperous in the city's history.

Three

BETWEEN THE GREAT FIRES

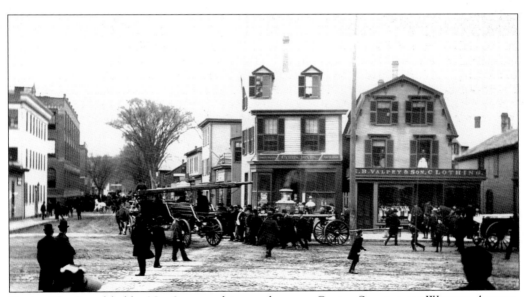

Engine No. 3 and ladder No. 3 respond to an alarm on Centre Street, near Western Avenue, in December 1890. The fire itself was minor, causing only a little over $100 in damages, but the photograph of the apparatus in action is unique.

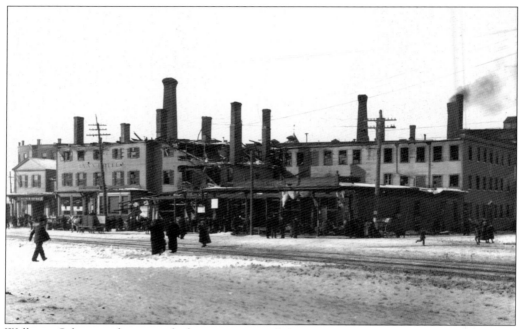

Wellman Osborne, who was unlucky in 1889 as well (see page 36), was the owner of the wooden block that stood on Western Avenue at Market Square that housed numerous other businesses as well. The building was a total loss in a fire on January 29, 1894. The Lynn Hotel (on the left), built in 1804, sustained considerable damage but was able to be saved. (Courtesy Conway collection.)

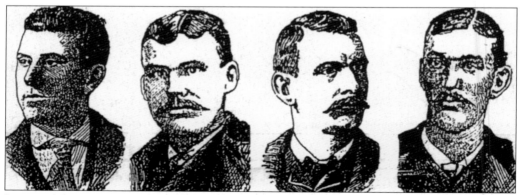

In one of the most tragic days the Lynn Fire Department has endured, four men were lost in a Munroe Street blaze on February 13, 1895. From left to right, they are Thomas E. Murray, hose man engine company 3; John Dolan, hose man engine company 3; Henry Skinner, captain chemical company 1; and Abram C. Moody, hose man engine company 3. (Moody was injured at the scene and died three days later in Lynn Hospital.)

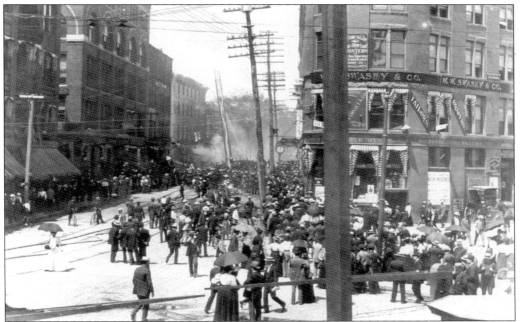

The Sagamore Hotel (fourth building from the left, with ladder in front) had been a landmark on Union Street since the 1850s and was for many years the only hotel in the central part of the city. Mark Twain was a guest there and according to the then-proprietor, William Thompson, conceived the idea for *Innocents Abroad* during his stay.

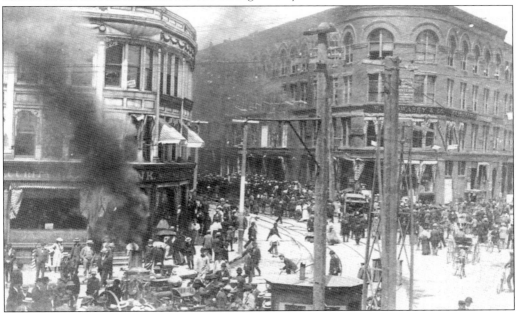

On July 3, 1895, the hotel was a total loss in a fire said to be caused by a young boy firing off a holiday firecracker prematurely. Above, the *Peter* M. *Neal*, steamer No. 1, rounds the corner of Union Street on its way to the scene. Two workers at the adjacent L. A. May Company, to which the fire had rapidly spread, were killed.

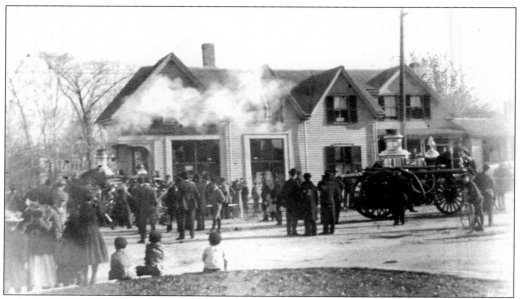

Swampscott engine No. 1 (left) and Lynn engine No. 5 simultaneously responded to a fire at the junction of Lewis and Ocean Streets around 1900. Damage was light, and the building still stands today.

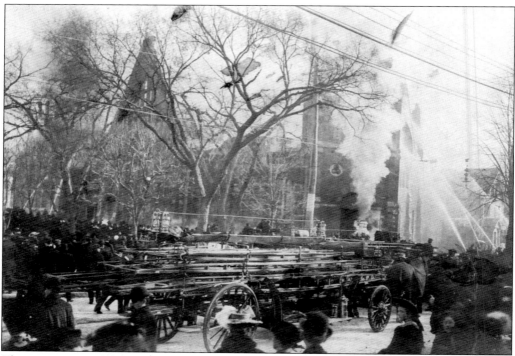

The great tower of the Washington Baptist Church was felled by the fire that ensued after an explosion of gas inside the building on January 15, 1905. The congregation rebuilt the following year but without the distinctive spire. (Courtesy Conway collection.)

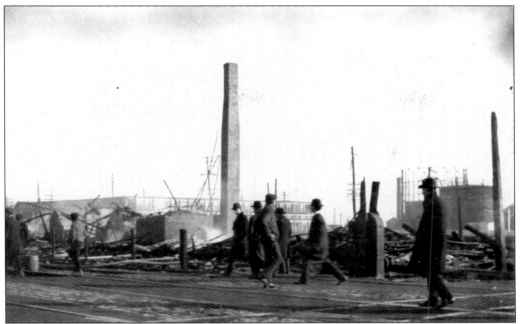

An explosion in the boiler house, located between the Harney shoe factory and the Owens box factory located at the corner of Commercial and Alley Streets, on December 6, 1906, caused the total destruction of both buildings as well as the adjacent Tufts and Friedman shoe factory, all wooden structures. The blast occurred just before 7:00 a.m., when few workers had yet arrived for the day.

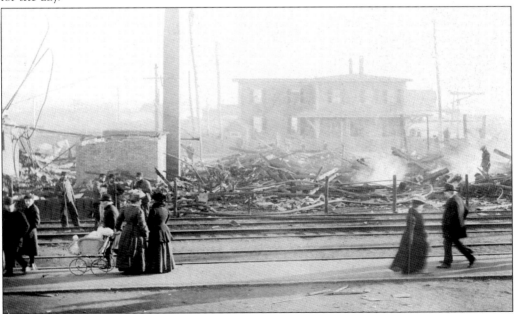

Although all three buildings were equipped with automatic sprinklers, unfortunately the explosion crippled the equipment. Gusty winds added to the difficulties faced by the firefighters. The predictable crowd gathered the next morning to view the wreckage.

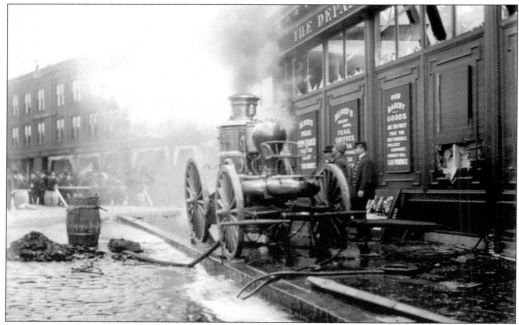

J. B. Bloods was for many years (into the 1960s) one of the largest and most popular supermarket chains in Lynn with several locations. The Summer Street branch was totally destroyed in a May 1, 1908, blaze. A larger brick building was erected on the same site, which still stands. Above is engine No. 2 by the still-smoldering ruins. (Courtesy Conway collection.)

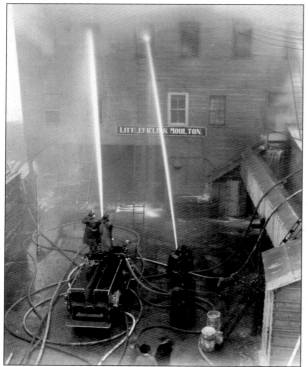

A workforce of mostly young women and girls were successfully evacuated from the Littlefield and Moulton box factory on Box Place on March 26, 1914. As may be seen in this photograph, the general congestion in the area complicated access to the fire, which was believed to have been deliberately set. (Courtesy Conway collection.)

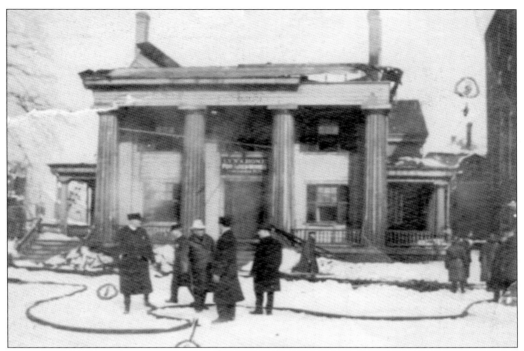

A two-alarm fire in the early morning hours of February 23, 1920, at the Lynn Home for Aged Women on North Common Street claimed the lives of four of the home's residents. The building was formerly the Nahant Bank.

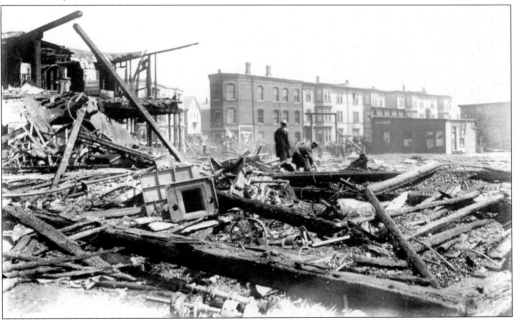

Hot tar in the Ryan Ideal Stain and Blacking Company, on lower Washington Street, ignited a fire that would eventually become a conflagration on April 21, 1922. A total of 38 buildings were either destroyed or badly damaged.

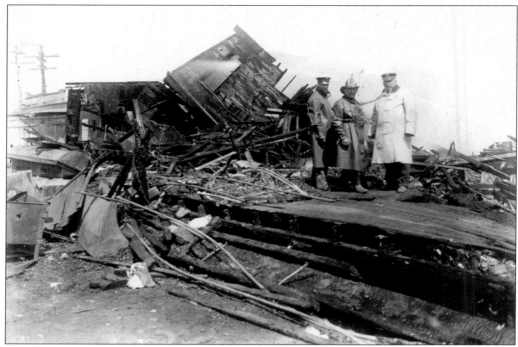

The Tibbetts Hotel and Restaurant, built in 1889, was the last building to be consumed by the 1922 Washington Street fire. Above, from left to right, Lt. Francis Rooney, Capt. James Rooney, and Chief Edward Chase survey the Tibbetts ruins. Chase blamed the rapid spread of the fire through the residential area surrounding the hotel on the highly flammable type of roof shingle then in wide use.

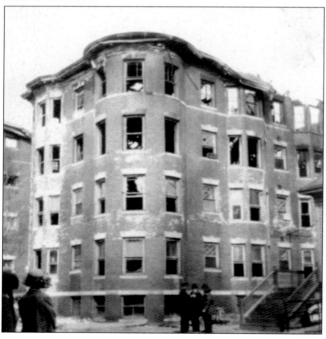

In the early morning hours of April 19, 1923, residents of the Essex Castle Apartments at the corner of School and Ellis Streets were awoken by the screams of their neighbors to find the building becoming engulfed in flames. The fire, which had started on the second floor, spread rapidly to the third and fourth by the time fire equipment could arrive.

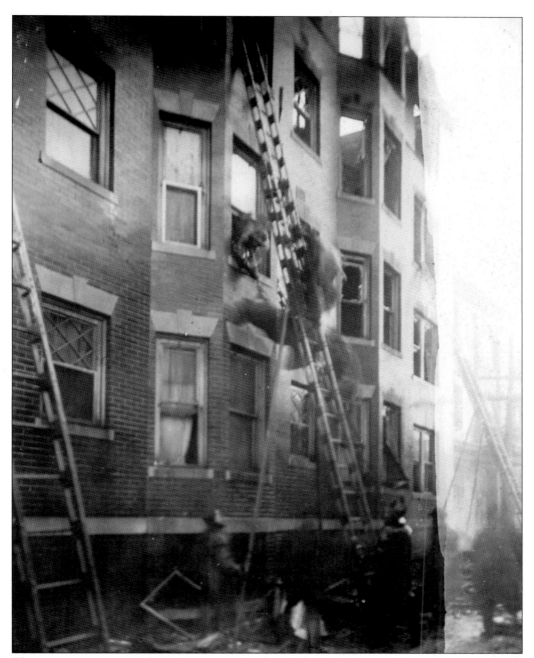

The main entryway was the only way in and out, and this lack of any additional means of egress in the form of fire escapes or ladders at the Essex Castle Apartments had tragic consequences. Over 20 persons were assisted down ladders, and an additional 17 jumped to safety nets below. Nevertheless, five persons inside were unable to escape, and two others later died from injuries sustained during the fire. Although the cause was traced to the apartment of a mentally disturbed woman, fire officials were harshly critical of the shoddy construction and insufficient exits.

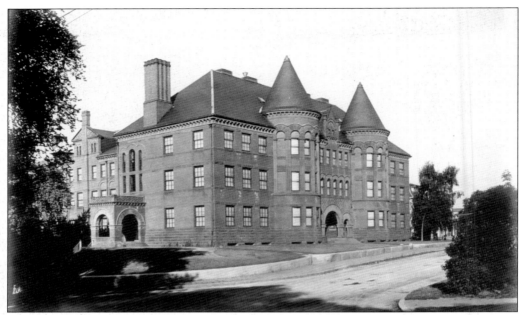

The elegant brick high school building, erected at Highland Square in 1892, originally housed both English and Classical courses until the Classical High building, on North Common Street, was constructed in 1911. By 1924, an additional gymnasium and a manual training school had been added.

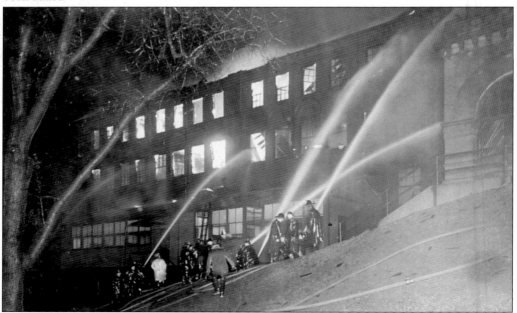

Shortly after midnight on the morning of March 29, 1924, a fire of unknown origin started in the basement, discovered by a Lynn police officer on a routine patrol. The numerous ventilating flues between the walls aided the rapid spread of the fire, which totally destroyed the original building and caused a loss of property to the value of $750,000. Of even more serious consequence, firefighter Arthur Preble lost his life combating the blaze.

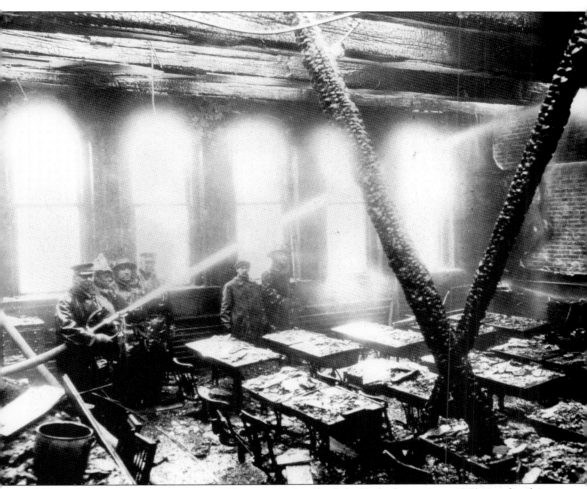

A national firefighting magazine, referring to the English High fire, wrote, "Many schools, considered 'fireproof' by the local authorities because of brick or other incombustible wall construction, offer no more protection against fire than this school. It is significant that the spread of this fire was checked with difficulty despite the fact that Lynn has a modern city fire department which was reinforced by aid from several neighboring towns and a severe rainstorm. Schools of this type and size in smaller towns with less adequate fire fighting forces form a serious conflagration menace." Above are the charred remains of a first-floor classroom.

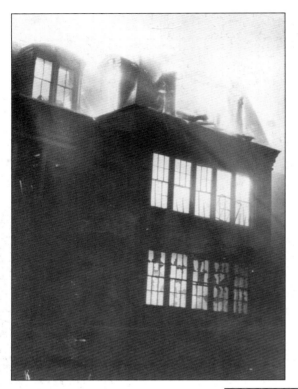

Just three years later, Lynn suffered yet another costly school fire when the Cobbet Junior High building on Franklin Street was set ablaze in the early morning hours of March 24, 1927. The source of the fire was apparently a first-floor supply room.

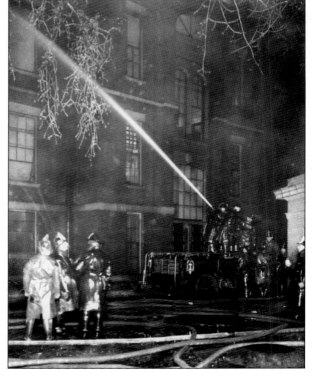

A strong easterly wind that blew embers onto the roofs of surrounding buildings added to firefighters' labors. Aid was sent from the surrounding communities of Swampscott, Salem, Peabody, Wakefield, and Marblehead to what would become a general-alarm fire. Damage exceeded $200,000.

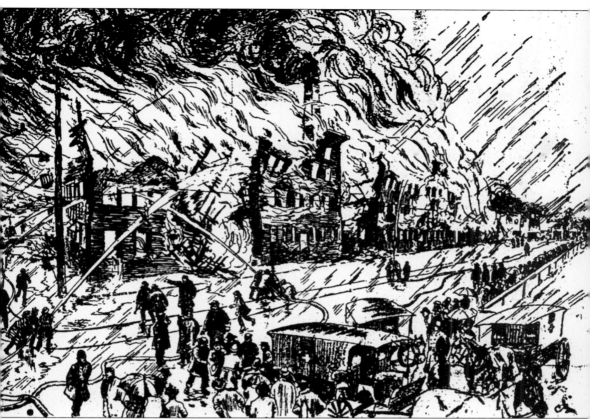

The greatest tragedy in Lynn's fire history occurred on November 8, 1928, when an explosion rocked the Preble Box Toe Company plant on Brookline Street. Twenty-one people lost their lives, perhaps most tragically a mother and five children living next door to the factory.

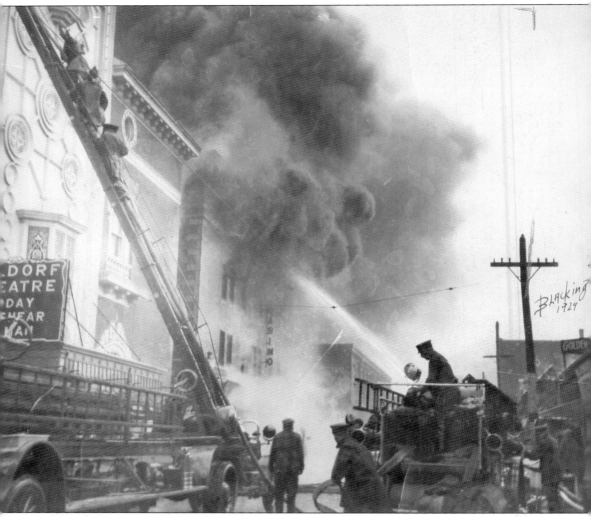

The Casino Dance Hall had suffered a small fire a few weeks prior to April 22, 1929, and it was believed that spontaneous combustion of some of the repair materials may have caused the blaze that gutted the Summer Street building, causing at least $65,000 worth of damage. Four workmen were evacuated without injury.

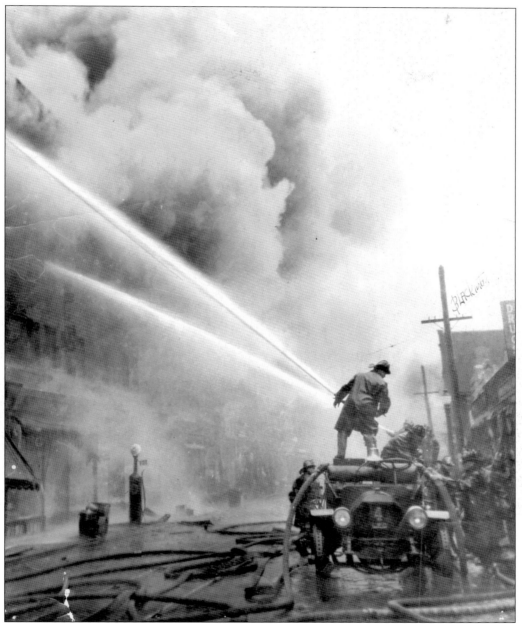

Department chief Edward E. Chase called for a general alarm immediately upon his arrival at the Casino Dance Hall scene. Prompt flooding of the building from all angles made it possible to confine the fire to the Casino Dance Hall alone, sparing the adjacent Waldorf Theatre and the Casino garage, at that time containing about 60 automobiles.

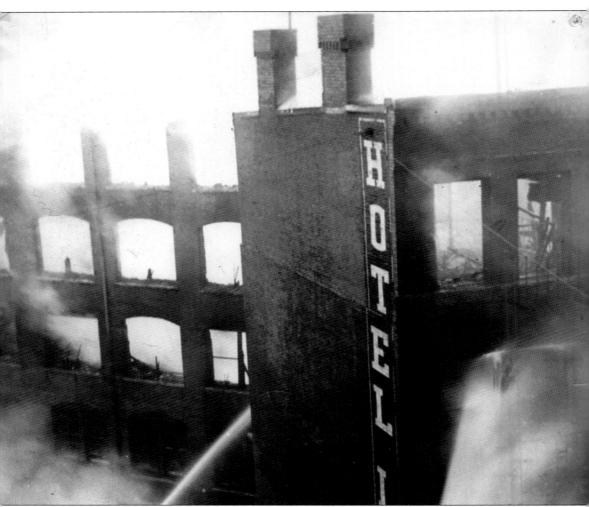

When a basement fire erupted at 4:00 a.m. on March 18, 1931, 3 people were killed, 6 were injured, and 45 rescued from the Hotel Lennox. The flames spread quickly up through the stores and offices on the first and second floors to the guest rooms on the top three floors, the speed can be attributed to the hotel's lack of a sprinkler system. Many of the guests were forced to jump from windows into awaiting fire nets, a procedure that can often cause panic and subsequent injury. Swampscott, Revere, and Peabody responded to the general alarm. The hotel stood where the current Edison Building is, at Broad and Exchange Streets.

A woman was killed and 14 firefighters were injured when a rooming house at the corner of Boston and North Federal Streets collapsed on July 7, 1933, after the flames had been effectively put out. Alterations had been in process in the building, which was thought to have lead to structural unsoundness.

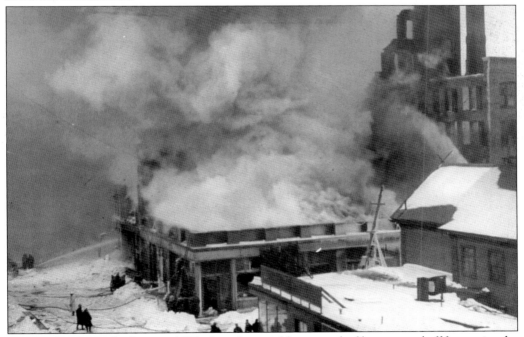

During a brief period in January 1935, when the sprinkler system had been turned off for repairs, the partially occupied Faunce and Spinney factory building at the corner of Almont and Blake Street burned from a fire of unknown origin. The fact that the adjacent buildings were well equipped with sprinklers was credited with preventing a conflagration. (Courtesy Conway collection.)

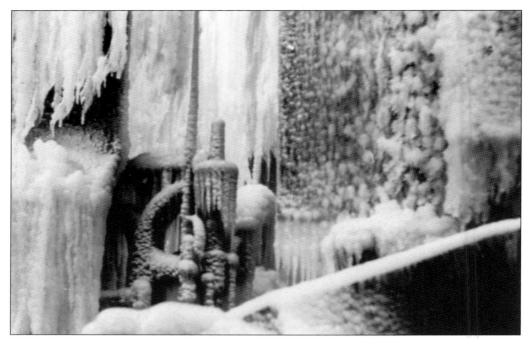

A tragic consequence of the subfreezing temperatures the night of the Faunce and Spinney fire was that a homeless man, who had taken to sleeping inside the factory at night, was burned to death. His remains were not recovered until July.

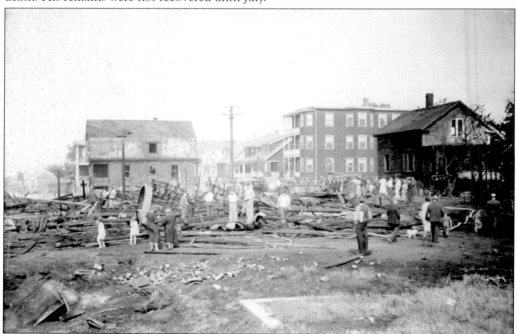

Britt Brothers' Boatyard at Raddins Street in West Lynn was destroyed in a general-alarm blaze on June 7, 1936. Cans of varnish and gasoline stored on site led to explosions, which caused damage to several surrounding buildings and were seen as far away as Somerville.

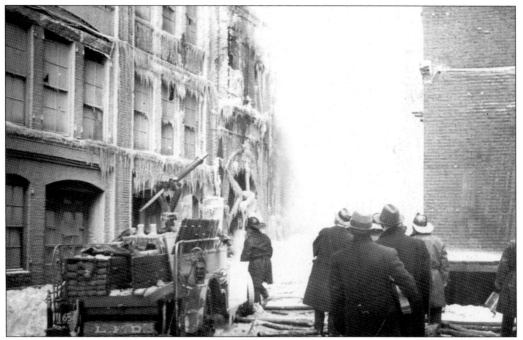

A fire at the building next door on Willow Street set the Boston Machine Works on fire on January 30, 1937, but the company would soon rebuild and be an extremely important contributor to the military during World War II.

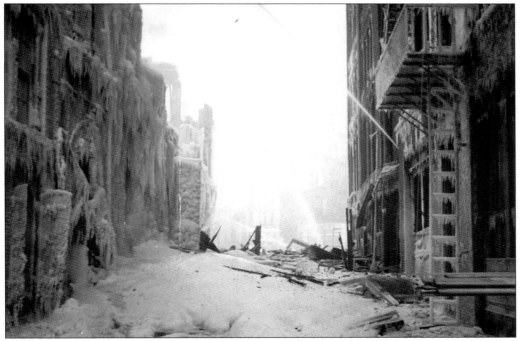

Subfreezing temperatures during the Boston Machine Works fire left Willow Street covered in icicles, giving it a rather other-worldly appearance.

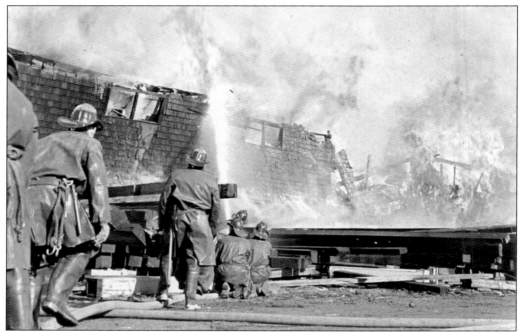

Careless cigarette smoking was blamed for the March 23, 1937, fire that destroyed the entire plant of the Atlantic Building Supply and Wrecking Company on Broad Street. A strong wind sent flames leaping into the air as high as 50 feet.

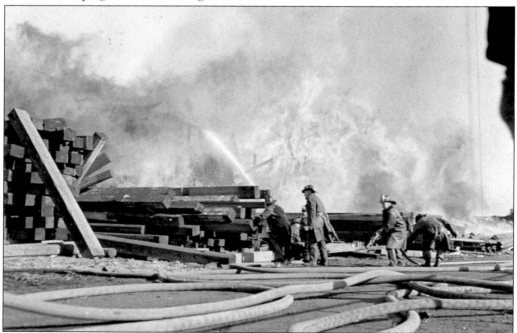

After raging out of control for over an hour, the blaze was eventually contained before any damage occurred to the adjoining businesses: Champion Lamp Company and the Lynn Gas and Electric Company.

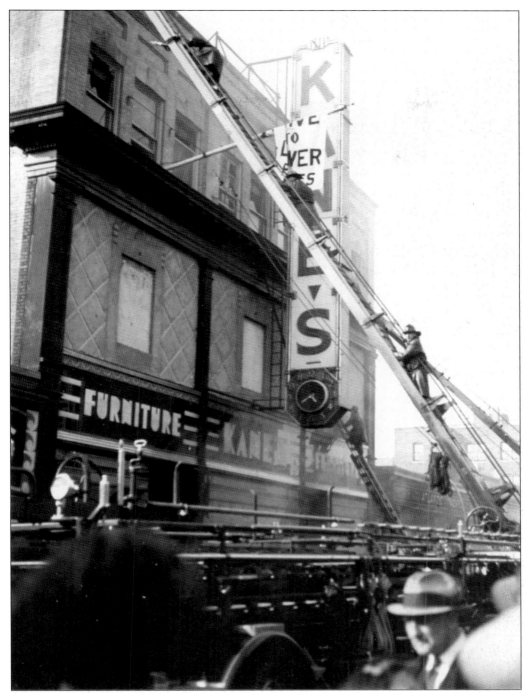

On April 28, 1938, Kane's Furniture Store, at 219 Union Street, was accidentally set afire, possibly by a short circuit in the radio department on the first floor. A newly installed airtight metal ceiling helped firefighters limit the damage to that one building, although three alarms were sounded and over $50,000 worth of damage occurred.

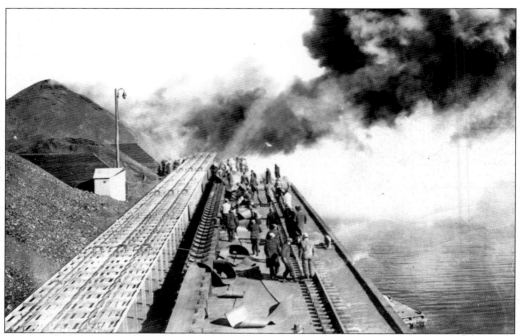

One of the most spectacular fires in the history of the city, as far as pyrotechnics are concerned, occurred at the Lynn Gas and Electric Company plant on February 10, 1938, with the spontaneous ignition of a coal pile.

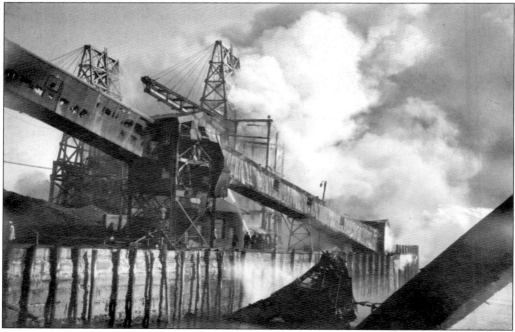

The fire soon spread to the adjacent 500-foot wooden wharf; and within a brief time, a general alarm was sounded when attempts to contain the blaze in the face of a steep wind proved unsuccessful.

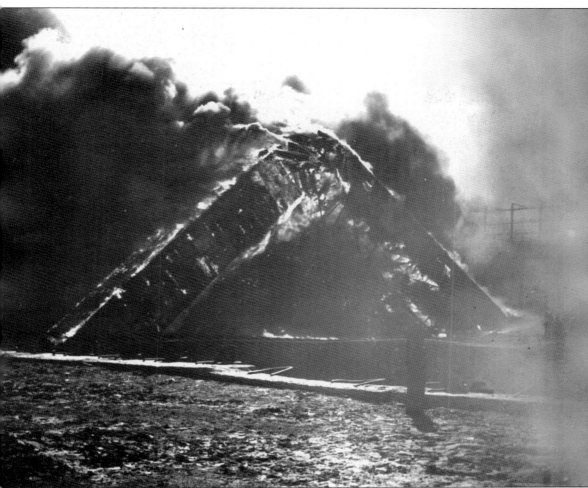

About one and a half hours into the Lynn Gas and Electric Company fire, the flames reached two coal towers that had been moved to the southerly end of the dock. The fire spread to the southernmost of the two towers, causing it to collapse. The other, although badly damaged, remained standing. The dense smoke from the quantities of burning coal added to the difficulty in combating the fire's spread. In the end, over $500,000 worth of damage occurred.

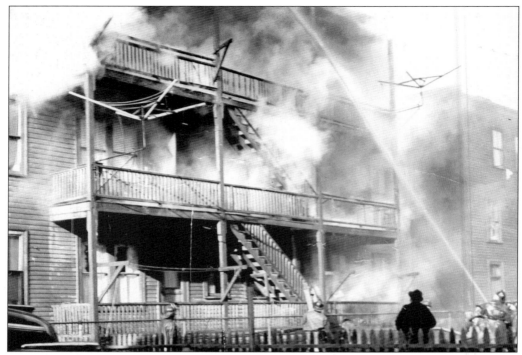

A January 1939, two-alarm blaze on Crosby Street demonstrates the hazardous conditions that were prevalent in many Lynn neighborhoods. Tightly packed, wood-frame tenement buildings such as these—some containing as many as 12 or 15 apartments—stood virtually no chance once the flames had taken hold, and fire quickly spread to adjacent buildings, as seen above.

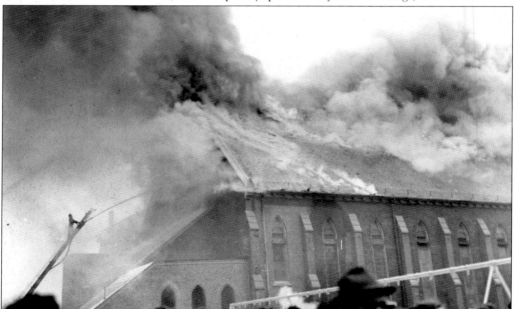

St. Mary's Church, at 6 South Common Street, was the city's oldest Catholic church, constructed in 1867. A few days after Christmas, on December 29, 1941, flames devastated the building.

Another view of the Saint Mary's fire shows the landmark steeple just as it becomes consumed by the flames. A large crowd gathered to observe, and many living today recall this as one of the worst fires they have witnessed, after the 1981 conflagration.

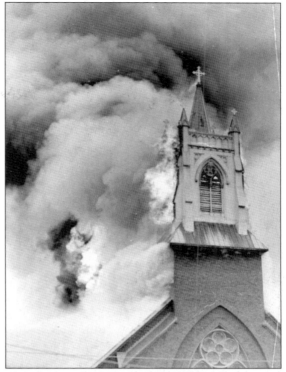

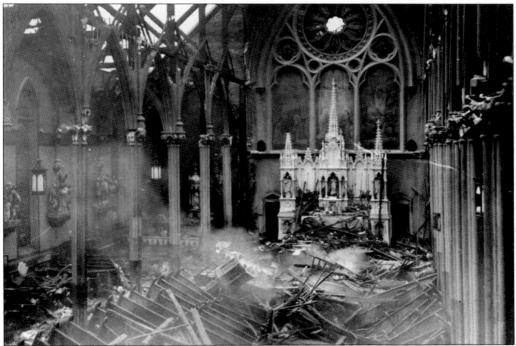

The church was entirely destroyed, leaving just one wall standing when the fire was finally extinguished. The parish rebuilt on the same site and dedicated a new edifice in March 1947.

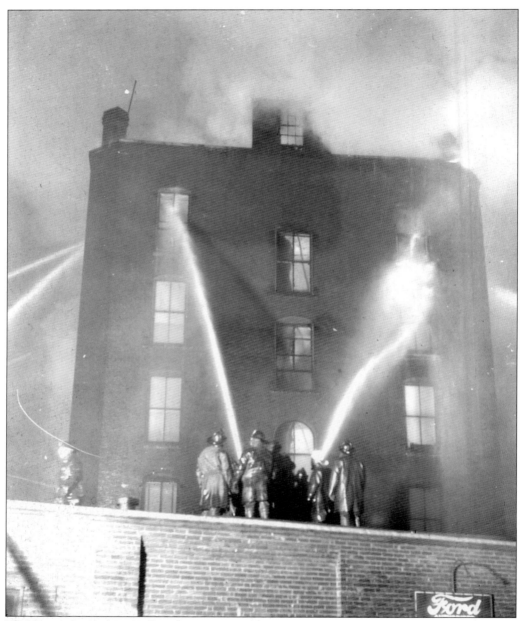

The fire at the Melvin Hall Apartments on Spring Street on January 20, 1942, was one of the most costly fires in terms of the loss of life in Lynn's history. The building, erected in 1896 and remodeled on several occasions, was a five-story, brick and wood-joist construction. Although state regulations at that time specified that no building of similar construction could be built higher than four stories without automatic sprinklers, no such safety measures had been added to the building.

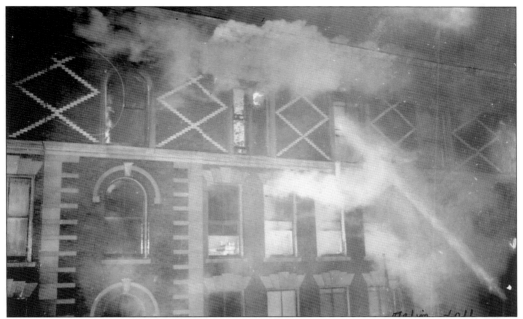

The blaze, which began at approximately 2:00 a.m., apparently started in the bottom floor, which housed a laundry and storage space, burned for some time before residents of the apartments on the top four floors were made aware. Flames spread quickly through the open elevator shaft and smoke filled the hallways, making access to exits difficult.

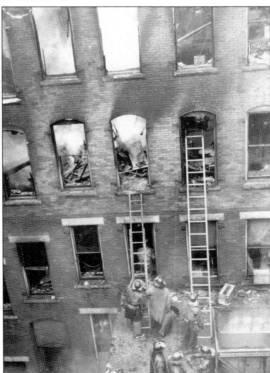

Firefighters were also hindered in their efforts to reach the trapped occupants by the thick smoke and were forced to follow the sound of screams and shattering glass to locate victims.

This is one of the life nets used at the Melvin Hall fire, in which 13 people lost their lives. In the fog of smoke and confusion, more than one person hit the edges of the nets and was injured, or missed entirely and was killed.

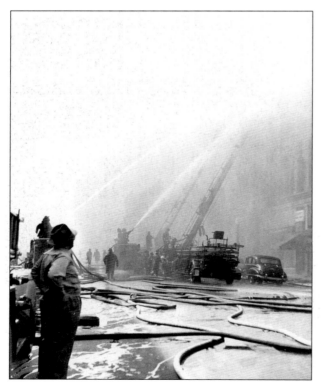

A Sunday afternoon fire in May 1950 affected a large block of retail stores on Market Street, between Oxford and Andrew Streets. Firefighters are aiming at the upper floors where the blaze started. (Photograph by Jim Ruth.)

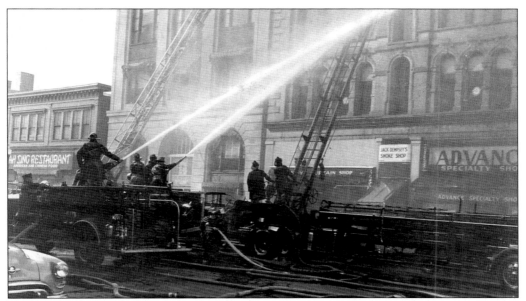

Since most retail business in the city was closed on Sundays, firefighters and apparatus had relatively easy access to the fire without interference from the traffic that would have clogged Market Street on most other afternoons. Among the businesses that were threatened were, from left to right, the Ah Sing Chinese restaurant, Jack Dempsey's Smoke Shop, and Advance Specialty Shop, a women's clothing store. On an upper floor was the popular Kahakalau Studio of Hawaiian Music. (Photograph by Jim Ruth.)

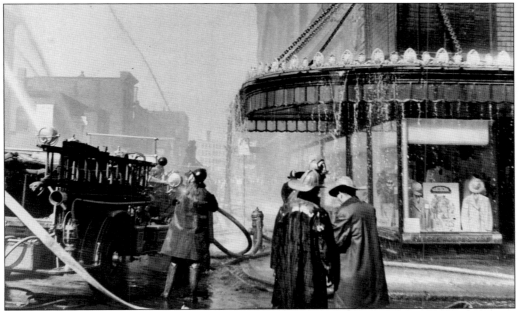

Water drips from the front of Samson's Clothing Store for Men on the corner of Market and Oxford Streets after the May 1950 fire had been brought under control. Directly across Oxford Street was Besse-Rolfe, which happened to have its lawn sprinklers going on the side of the building, probably sparing it from any fire damage.

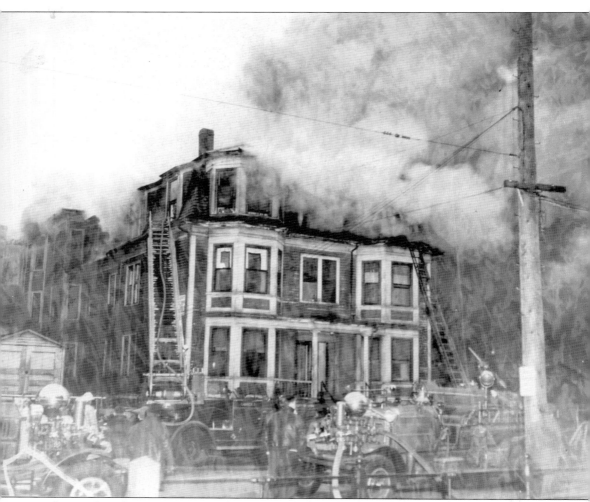

In another disastrous rooming-house fire reminiscent of the Essex Castle Apartments and Melvin Hall tragedies, residents were forced to jump from the windows of the West Moreland House, at 45 Stewart Street, as flames rapidly engulfed the three-story wooden structure in the early morning hours of January 29, 1955. Four persons were killed at the scene, and eight others suffered serious injuries. Most of the residents of the 45-room building were elderly or retired.

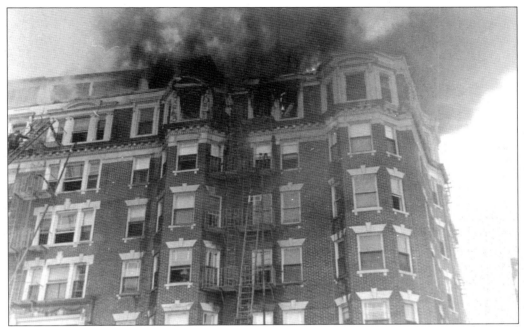

The Breakers, a landmark apartment building on Lynn Shore Drive, was built in 1919–1920 and named after the Vanderbilt summer cottage in Newport, Rhode Island. It stands seven stories high and was the tallest elevator building in Lynn at the time. Fire broke out on the seventh floor on May 25, 1956. (Courtesy Conway collection.)

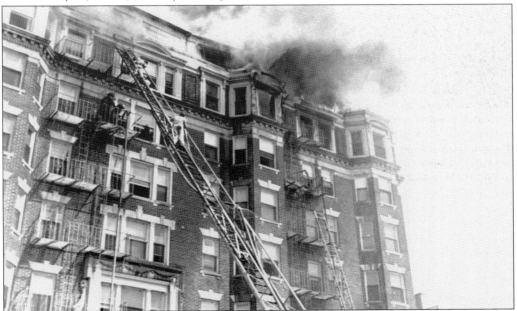

Although the fire left many of the Breakers's 82 families in residence homeless, there were no fatalities, in part due to its midmorning start when few were caught sleeping. Eleven firefighters were able to escape from the seventh floor mere moments before the roof collapsed. (Courtesy Conway collection.)

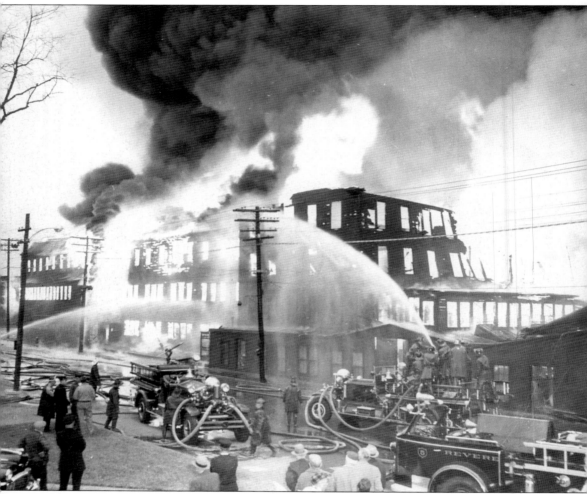

The Agoos Tannery buildings on Boston Street were for sale, the machinery inside in the process of being claimed by industrial salvage firms, when fire struck on November 29, 1956. The sprinkler system had been disconnected several weeks prior to the fire, but Chief Scanlon, having been made aware of that fact, had ordered that the building be placed on round-the-clock watch because of the highly flammable nature of the chemicals used in the leather-making process, which had no doubt saturated the building.

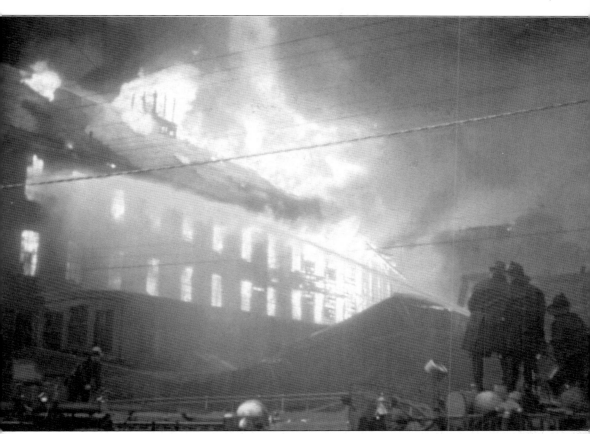

Seven neighboring communities, in addition to a 300-strong force from Lynn itself, battled the Agoos Tannery fire, which generated some of the most intense heat and highest amount of water usage of any fire prior to it. Although the heat damaged some 400 feet of high-voltage wire, leaving large parts of the city temporarily without power, the damage was otherwise contained to the tannery site itself. The danger of the fire spreading to Lynn Hospital, a mere 200 yards away, had been of particular concern. (Courtesy Conway collection.)

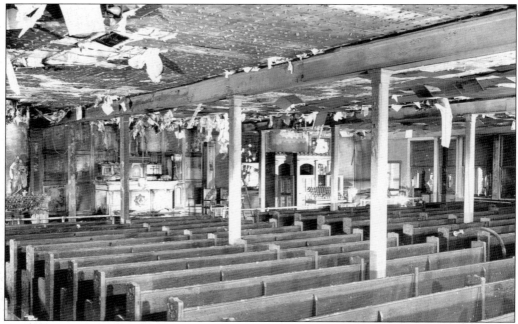

Only 15 years after the loss of their original church building, and a year and a half after an earlier fire at the identical site, St. Mary's chapel suffered extensive damage once again. The August 21, 1956, blaze, believed to be deliberately set, was blamed by Chief Joseph E. Scanlon on a "firebug."

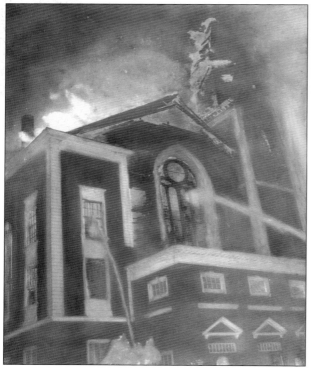

Church buildings are particularly susceptible to fire, and few Lynn denominations have been spared the heartache of seeing a beloved structure destroyed. St. Paul's Methodist Church on Union Street was not among that lucky number. On April 9, 1958, a four-alarm blaze broke out in the 97-year-old building, leaving it a total loss. In total, 11 other communities lent aid, and 15 Lynn firefighters were injured.

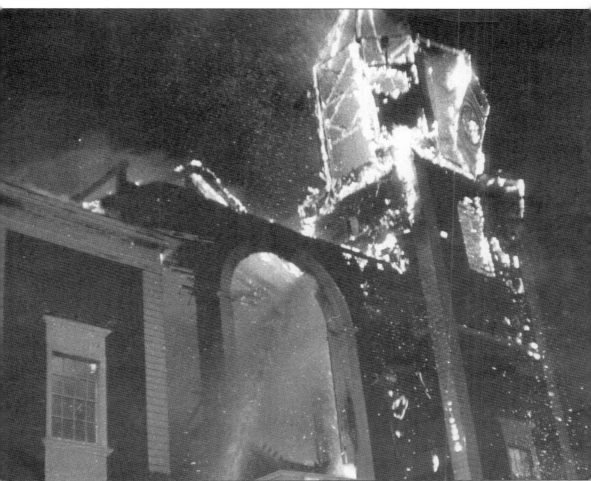

Shown above is a dramatic view of St. Paul's Methodist Church, on Union and Chestnut Streets, moments before the total collapse of its steeple. A new structure was built on the same site and was dedicated in 1960.

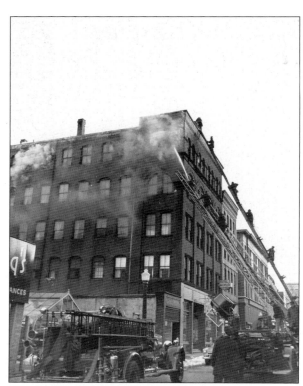

Lynn ladders No. 1 and No. 3 are seen in action at the Benson Hotel on Oxford Street during the March 8, 1957, fire.

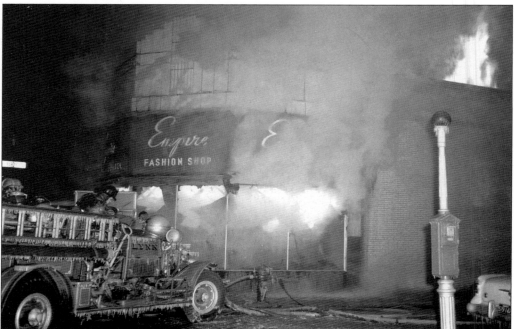

Market Street's retail center was hit once again on January 6, 1959, when Woolworth's 5-and-10-cent store and other establishments at the Liberty Street crossing caught fire on a subfreezing night. Here ladder No. 6 battles the flames at Empire Fashion Shop.

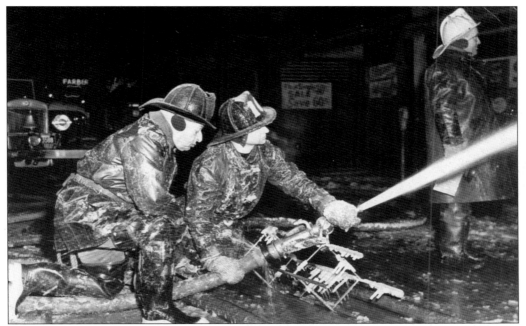

Firefighter Donald McDonald and Chief William Lenihan are seen at the Woolworth fire; the effects of the cold are evident in the slush forming at their feet and the icicles already beginning to drip from their clothing and equipment.

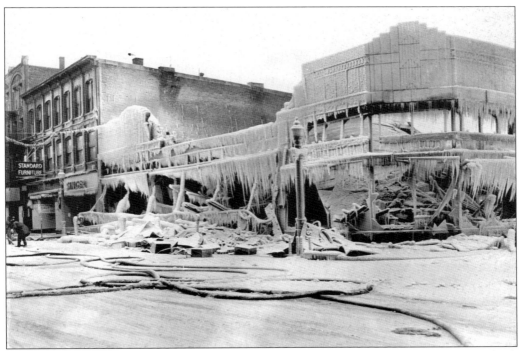

The next day Woolworth's and Empire Fashion Shop were twisted, ice-covered ruins, both total losses.

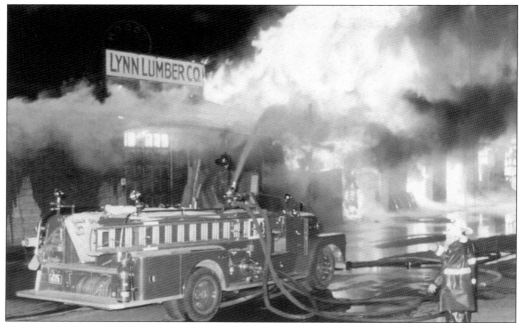

Lynn Lumber Company on Commercial Street was the site of a spectacular general-alarm blaze on the night of May 23, 1964. The very nature of the product makes lumberyards highly susceptible to fire, which can quickly get out of control as readily seen here. (Courtesy Conway collection.)

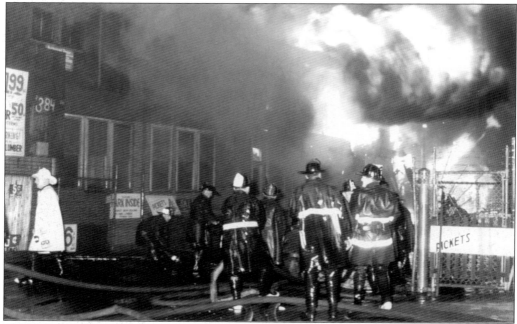

A little over a year later, on July 4, 1965, the truth of that statement was demonstrated once again when Feldman Lumber Company on the Lynnway was similarly consumed. (Courtesy Conway collection.)

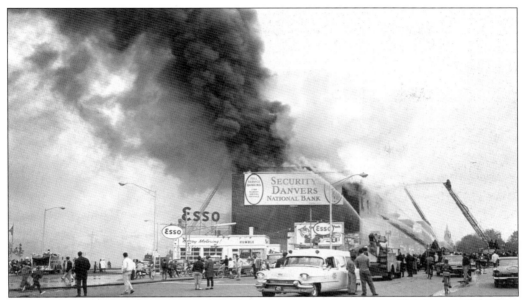

Stuart Furniture at Market Square was the site of a general-alarm fire on October 15, 1966. The Esso gas station in the foreground was at the location of the old Lynn Hotel. As usual, a large contingent of spectators has turned out. (Courtesy Conway collection.)

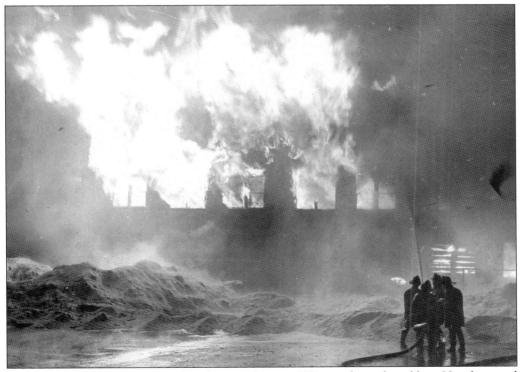

The Hotel Baldwin was consumed by flames in January 1971 in a three-alarm blaze. Here hose and crew from Lynn ladder No. 1 attack the fire from the building's side. (Photograph by Walter Hoey.)

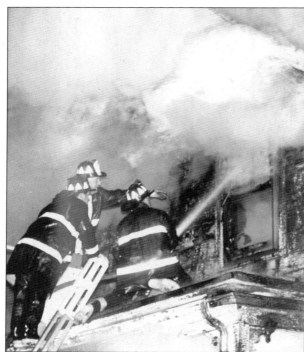

The 1970s were a particularly difficult period for Lynn and its fire department as arson became a regular peril, diverting money, equipment, and manpower from legitimate fire scenes and badly overextending the department. Here firefighters battle a two-alarm blaze on Clifton Avenue in May 1972. (Photograph by Walter Hoey.)

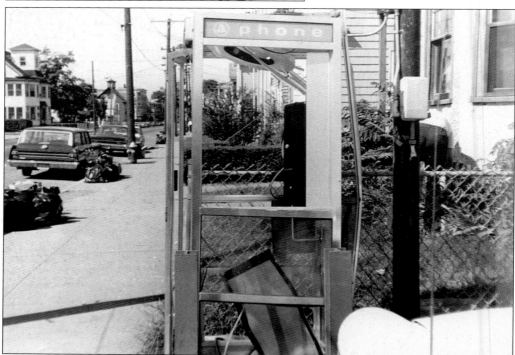

Not necessarily a major fire, but perhaps a unique one, this is an explosion inside a telephone booth on Western Avenue on June 27, 1975. Its origins were considered suspicious. (Courtesy Conway collection.)

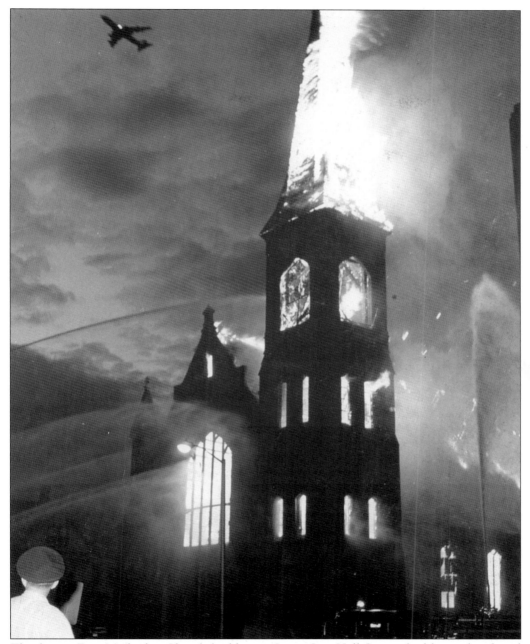

The former First Methodist Church building at Lynn City Hall Square had been abandoned in 1968, 90 years after its construction, and was used from 1969 until 1971 as a temporary courthouse. Fortunately the church's treasures had been removed before an incendiary fire destroyed the building on the night of June 12, 1972. These treasures included brass candelabra, memorial windows, and—most importantly—its Paul Revere bell.

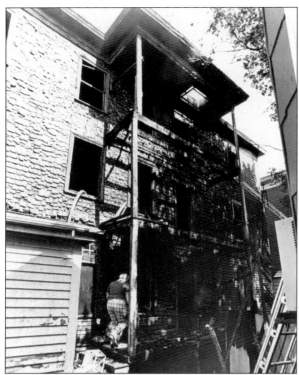

The popular grocery store on Fluke's Corner at 190–194 Chestnut Street was badly damaged, along with the apartments above it, in a three-alarm fire on July 30, 1975. (Courtesy Conway collection.)

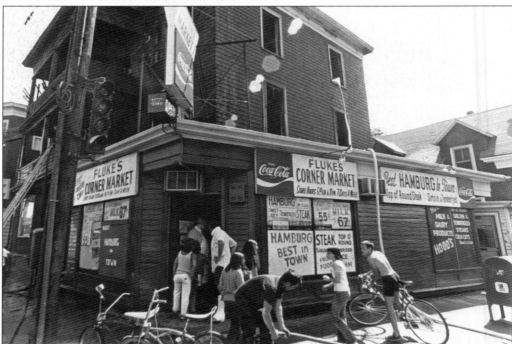

The following day, curious neighbors and passersby, including a contingent of young bicycle riders, stopped in to check on the damage. (Courtesy Conway collection.)

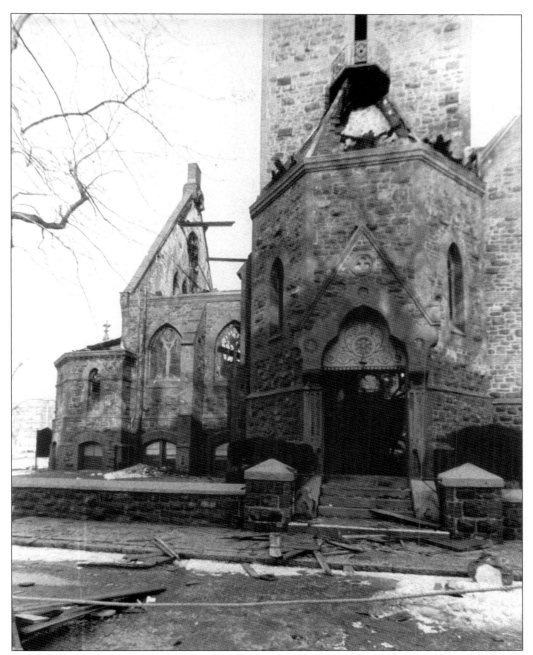

Over 400 firefighters from 14 surrounding communities battled the six-alarm, January 7, 1976, blaze at the over-100-year-old Unitarian Universalist Church on Nahant Street, one of the city's most attractive religious structures. Arson was strongly suspected. A series of smaller fires were ignited on the surrounding buildings. The fire also forced out a daily lunch program for the elderly. (Courtesy Conway collection.)

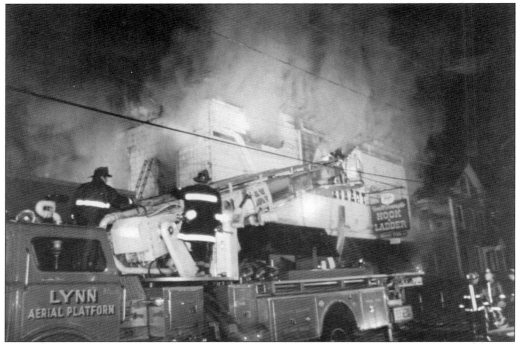

Lynn ladder No. 2 responds to an alarm at the Hook and Ladder Restaurant at 91 Commercial Street on July 28, 1975. (Photograph by Peter Aloisi.)

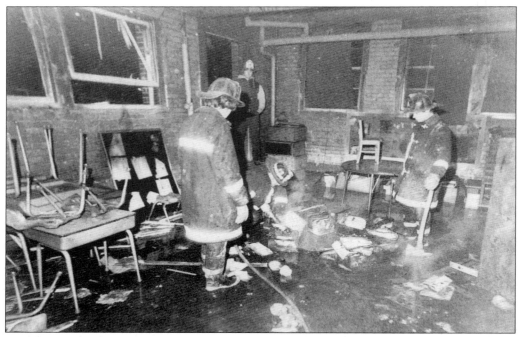

Firefighters poke through the rubble in one of the classrooms at the Brickett School, at 123 Lewis Street, after it was damaged in a nighttime fire on February 3, 1976. (Courtesy Conway collection.)

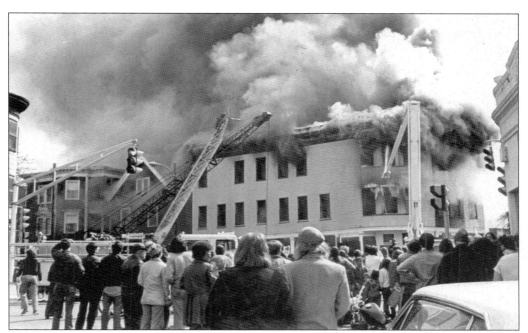

The building at the corner of Lewis and Cherry Streets was in the process of being demolished on April 4, 1976, when it was totally destroyed by a fire started by two teenagers living nearby.

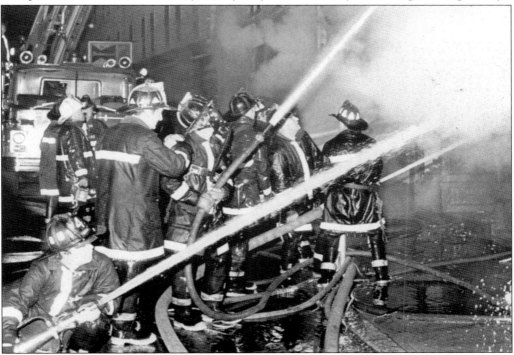

The following day, a five-alarm fire destroyed several buildings on Union Street between Green and Pinkham Streets on April 5, 1976. The losses included a used furniture store and an apartment building.

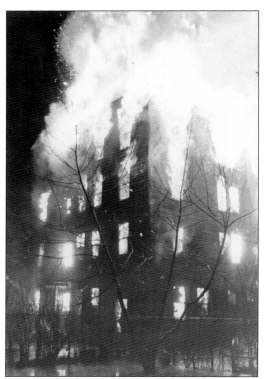

A view of the same fire from Pinkham Street shows the full extent of the fire at its height.

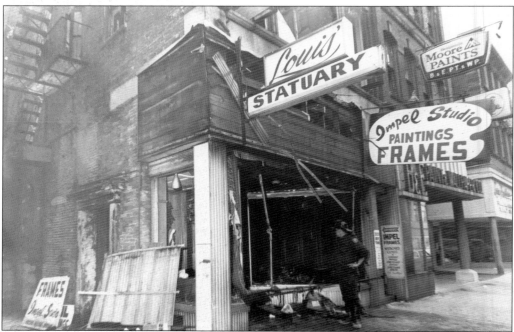

Impel Studio, a framing shop, was in ruins after a four-alarm fire on Munroe Street in August 1976. The building originally dated to the 1860s and had been used as a shoe factory. Here an unidentified firefighter surveys the damages. (Courtesy Conway collection.)

Four

THE CONFLAGRATION OF 1981

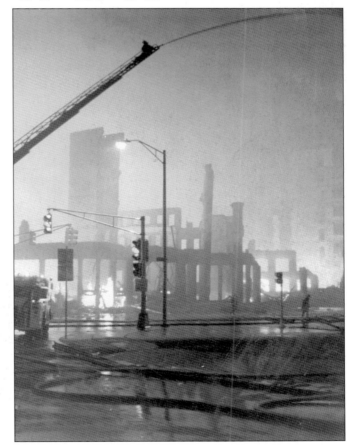

A lone firefighter is seen operating a ladder pipe onto the fire in the Vamp Building. This is a view looking down Broad Street from Spring Street. Rubble from what was once the heart of Lynn's shoe district is all that remains. Portions of the falling buildings lie in the street along with abandoned hose lines. By this time firefighters had been relocated to other buildings that were actively on fire. (Photograph by Arthur W. Dunn.)

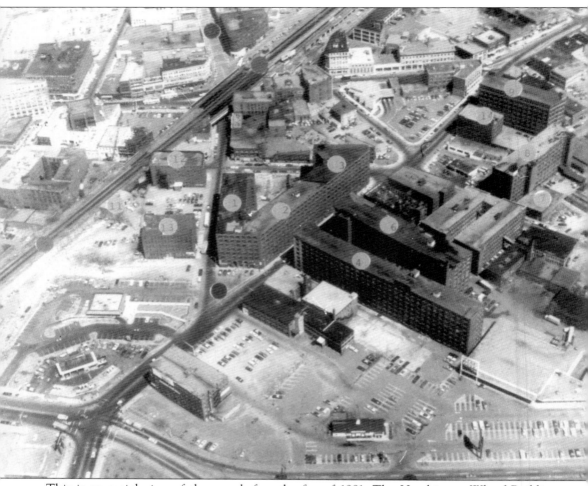

This is an aerial view of the area before the fire of 1981. The Hutchinson Wharf Building (36), Marshall's Wharf Building (4), Benson Shoe (9), and the Vamp Building (1, 2, 3) are all eight-stories high. The fire originated in the Hutchinson Wharf Building, which was in the process of being torn down. The fire bypassed the Grenmere-Hub Die Building (14) and ignited Benson Shoe. (Courtesy Conway collection.)

The fire started in the Hutchinson Wharf Building shown on the left. It was eight stories, measured 60 feet by 300 feet, and was in the process of being demolished. The Marshall's Wharf Building, shown at the right, was being remodeled and measured 60 feet by 400 feet. Both buildings were completely destroyed by the fire. The building in the middle had been torn down prior to the fire. (Courtesy Conway collection.)

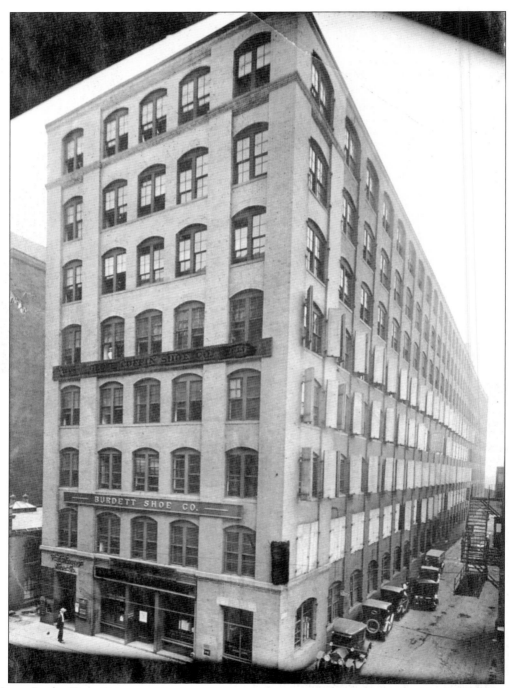

Lynn Realty Trust Company No. 6 at 278 Broad Street was later known as the Marshall's Wharf Building (the street on the right of the above photograph is Marshall's Wharf.) In the 1919 photograph above, the building was equipped with metal fire shutters on the side windows. If these had still been in place at the time of the fire, the outcome—a total loss—might have been different.

This view is of the Elm Shank and Heel Company, a shoe shank manufacturer located at 25 Marshall's Wharf directly behind the Musinsky shoe store at 292 Broad Street. To the left is Goldberg's Furniture Warehouse; on the right is the Vamp Building. (Courtesy Conway collection.)

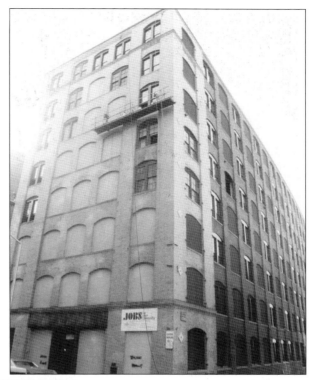

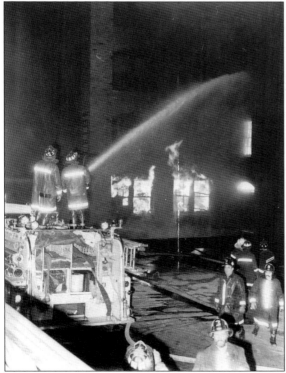

The fire began in the rear of the Hutchinson Wharf Building, the rear 35 feet of which had already been removed. This photograph shows heavy fire in the front right side of the building. Police officer Bill Foley was driving by at the early stages of the fire and took this amazing photograph. (Courtesy Conway collection; photograph by Bill Foley.)

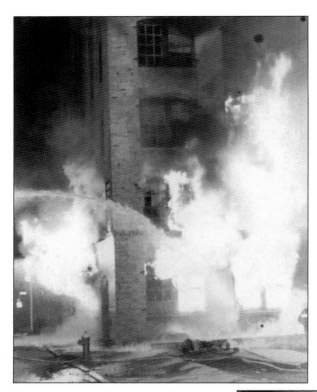

Moments later, fire had complete control of the first floor and was spreading to the second and third floors of the Hutchinson Wharf Building at 262–264 Broad Street. (Courtesy Conway collection; photograph by Bill Foley.)

The Hutchinson Wharf Building is now fully involved in fire. Apparatus that was initially positioned in front had to be relocated. Lynn police officer Bill Foley, who took this photograph, reported that it took less than five minutes for the fire to engulf the entire building. (Courtesy Conway collection; photograph by Bill Foley.)

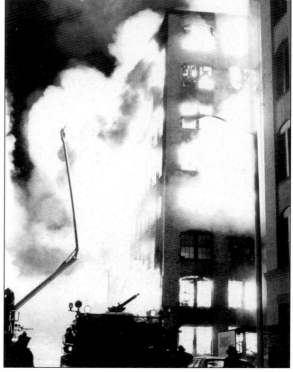

The Hutchinson Wharf Building is on the right. Already the flames have crossed Broad Street to the Vamp Building, on the left. The ladder truck was originally located in front of the fire building. When conditions rapidly deteriorated, the truck was moved with the firefighter still on the ladder. (Courtesy Conway collection.)

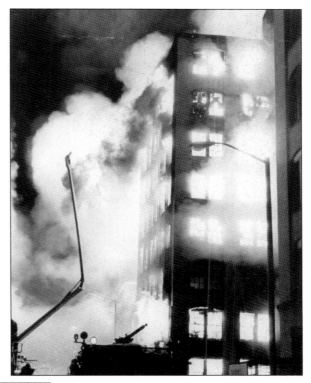

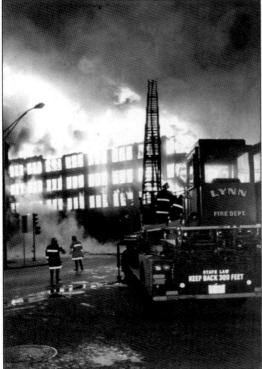

Heavy fire has now taken hold of the five-story building on the southeast corner of Broad and Washington Streets. Lynn's ladder No. 1 is shown after its relocation from the front of the building of origin. Chief of department Joseph Scanlon is to the left of ladder No. 1. (Courtesy Conway collection.)

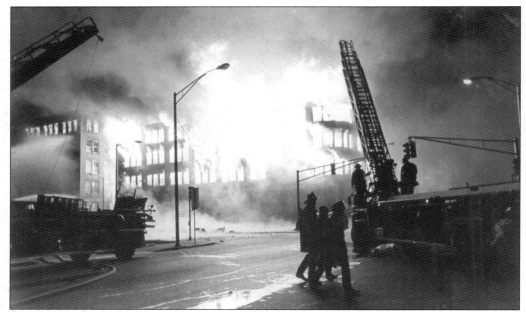

A Salem ladder company on the left and a Lynn ladder company on the right are setting up at the intersection of Broad and Spring Streets. Heavy fire has taken complete control of the building shown above and is seen extending down Washington Street, spreading to the five-story building to its left. Both buildings were completely destroyed. (Courtesy J. Clark Wilson.)

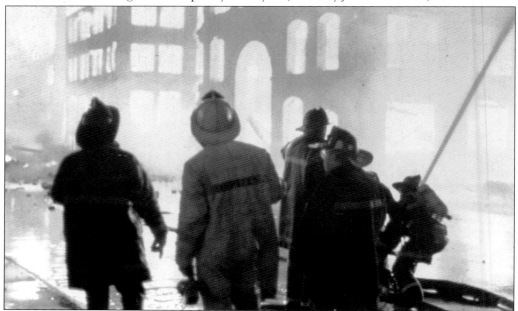

In another view of the fire's point of origin, the Hutchinson Wharf Building (with arched doorway), and the vacant three-story structure at 252–258 Broad Street are now both fully involved. The fire continued to spread to the left and right, destroying a total of 18 buildings. Deputy chief William Conway is at the center in the white coat. (Courtesy Conway collection; photograph by Murray Young.)

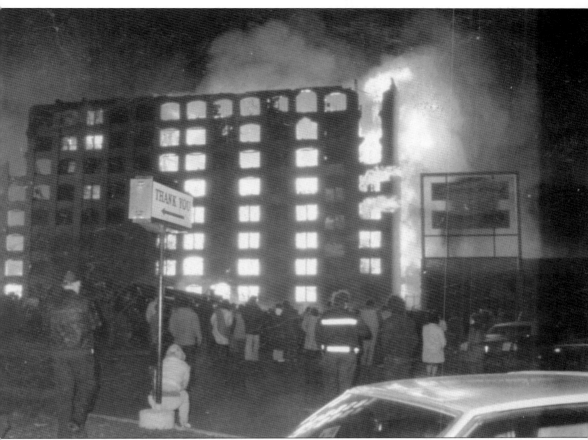

The left rear portion of the Marshall's Wharf Building is totally consumed by fire. This building was nearing completion of a $15 million transformation from shoe shops to industrial condominiums. This photograph was taken moments before the upper three floors of the rear wall collapsed onto and through the roof of the building next door. (Courtesy Conway collection; photograph by Bill Noonan.)

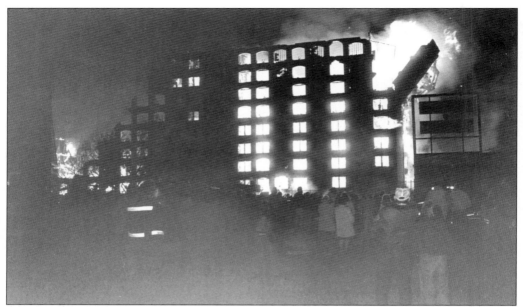

The Marshall's Wharf Building was eight stories in height and 400 feet long, facing Broad Street. Located in the rear was a row of single-story stores. The nearest was Roosevelt's Flea Market, formerly a Stop and Shop. Here the front of the Marshall's Wharf Building is almost totally destroyed, the rear is fully involved in fire, and the wall is falling onto the flea market. (Photograph by Bill Noonan.)

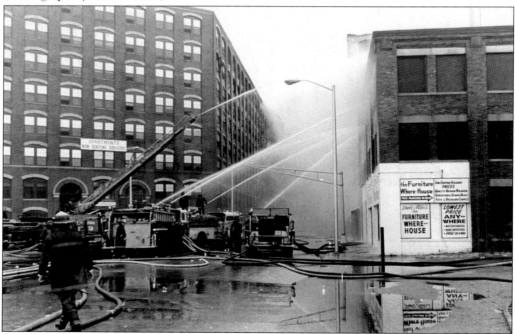

This view looks down Broad Street toward Swampscott. Heavy fire on the right side of Broad Street extended across the street, resulting in heavy damage to the Vamp Building on the left, at 7 Liberty Square. (Photograph by Bill Noonan.)

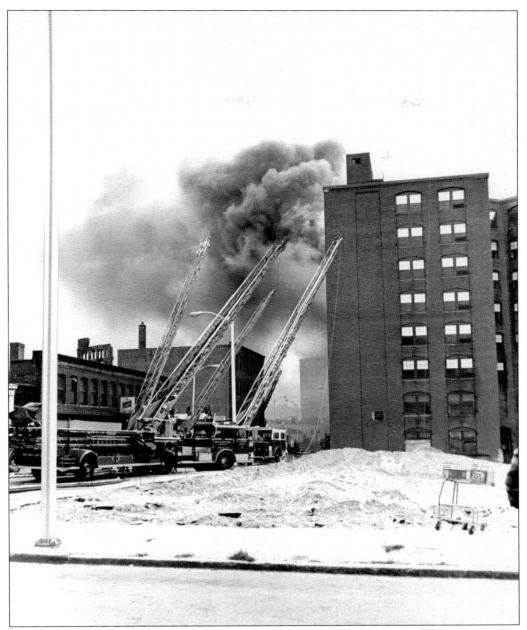

Ladder trucks are in position on the Washington Street side of the Vamp Building in anticipation of the spread of fire in that direction. The apparatus is located away from the building in case of the event of a collapse. The vacant lot in the foreground was in the process of becoming a parking lot for the new tenants of the Vamp Building. About three years earlier, a five-story shoe factory that occupied this lot was destroyed in a fire. (Photograph by Bill Noonan.)

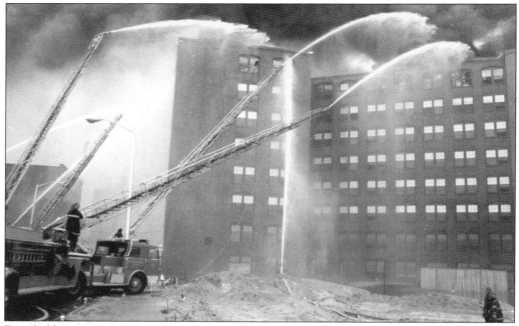

Four ladder pipes and many heavy stream appliances battle the fire in the rear of the Vamp Building. Once the largest building in the world devoted to shoe manufacturing, it had been converted to housing and the first tenants had only taken up residency the Monday before the fire. (Courtesy Conway collection; photograph by Peter Aloisi.)

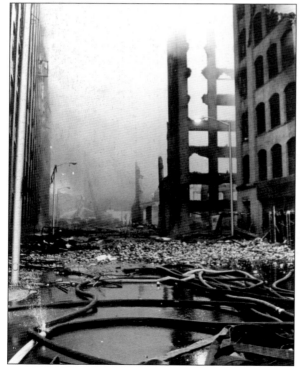

This section of Broad Street was once lined with multi-storied shoe shops. The two buildings on the right and the one on the left were eight stories each. This view down Broad Street from Liberty Square shows the destruction of the buildings in the foreground while the fire is still burning further down at the Benson Shoe Building. Many hundreds of feet of hose were abandoned and destroyed when the buildings collapsed. (Photograph by Len Muise.)

Because of the fear and the eventuality of the buildings collapsing, apparatus was located accordingly. This photograph shows men and equipment operating in Liberty Square in front of the Vamp Building. Musinsky shoe store is on the right of the picture; on the left center is all that remains of the Hutchinson's Wharf Building. (Courtesy Bill Noonan.)

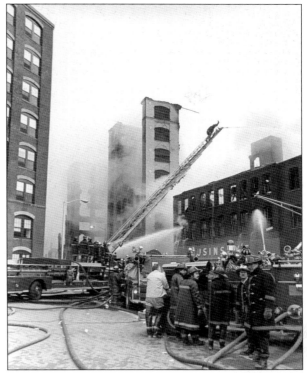

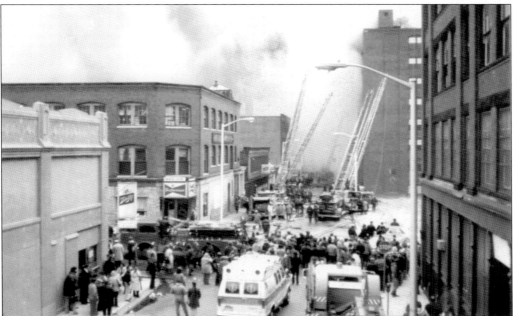

Crowds of curious spectators view the fire from all locations possible. In this photograph taken from the railroad bridge on Washington Street, ladder trucks are in position around the Vamp Building on the right. The three-story red brick building on the left corner is the new home of the Lynn Museum and Historical Society. (Courtesy Conway collection.)

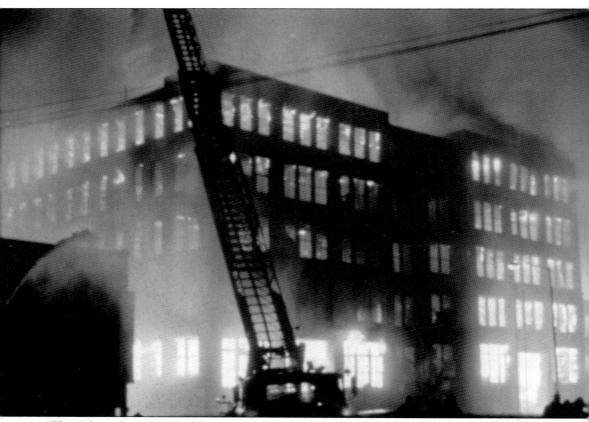

The Adam's Drug Building located at 669–685 Washington Street was five stories high with a basement. It had two long wings that were connected in the front forming large letter U. Residents from the Vamp Building across the street who were evacuated when the fire entered Washington Street had to leave by the rear exits because of the intense heat. (Photograph by Vaughn.)

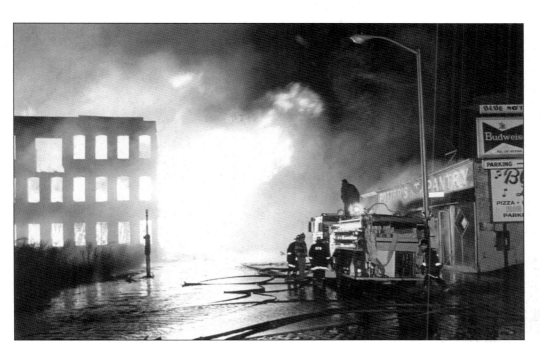

This view looks down Washington Street from the Lynnway. Fire blowing out of the three-story building on the left would ignite Potter's Pantry, a catering business, totally destroying it. (Courtesy Conway collection; photograph by Bill Noonan.)

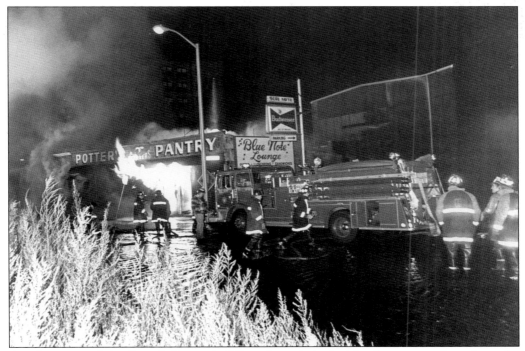

Another view of the Potter's Pantry building shows it ignited by the extreme heat from the burning buildings across the street. The engine is from Stoneham.

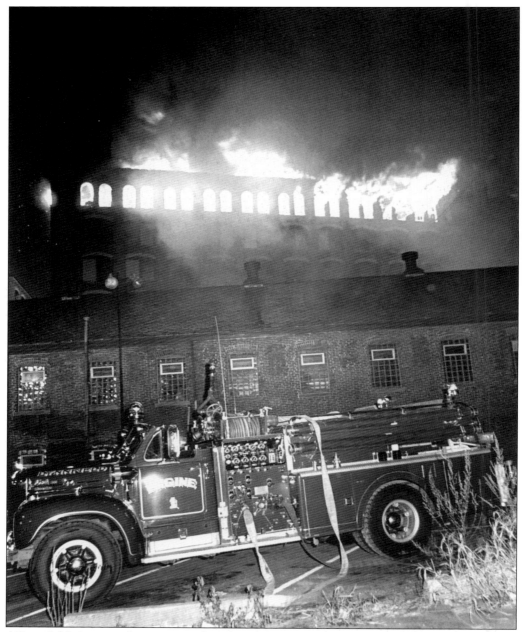

A Lynnfield engine is shown in a parking lot on Farrar Street. The building in the foreground is part of the Sterling Machine Company complex, which suffered moderate to slight damage to its buildings. In the rear is the Benson Shoe Building; the fire entered the top floor of the eight-floor building and burned downward. In this photograph, the top floor is fully involved. (Courtesy Conway collection; photography by Bill Noonan.)

Lynn's aerial platform, also called a bucket, after relocating many times during the fire, is setting up on Broad Street near the corner of Exchange Street. Heavy fire has total control of the top floor of the Benson Shoe Building. The fire continued to burn downward and eventually this wall collapsed onto Sam's Grill and the Olympic Auto Body shop. The building on the left is part of the Sterling Machine Company. (Courtesy Conway collection; photography by Bill Noonan.)

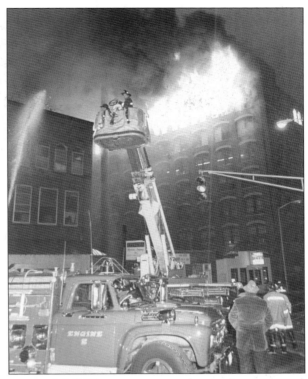

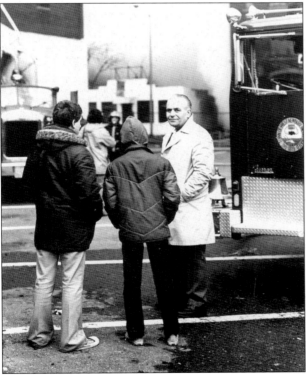

Sam's Grill, a small restaurant on Broad Street, was open during the early part of the fire. When the left wall of the Benson Shoe Building collapsed, it fell through the roof and the interior of both Sam's Grill and the adjacent Olympic Auto Body shop. Both businesses would be reconstructed at the same locations. Sam Markopoulos, owner of Sam's Grill, is in the light coat. (Courtesy Ray Whittier.)

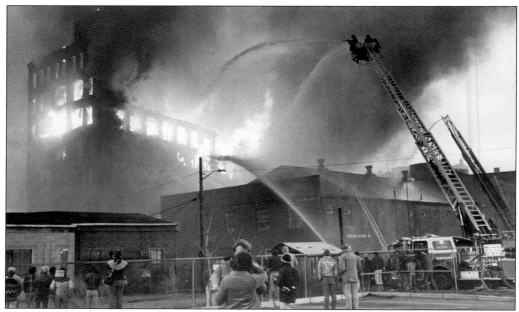

The top four floors of the Benson Shoe Building are heavily involved in fire in this view from the building's rear on Farrar Street. A Nahant ladder extends over the Sterling Machine Company building, fighting the flames that would eventually consume all eight floors. (Courtesy Bill Noonan.)

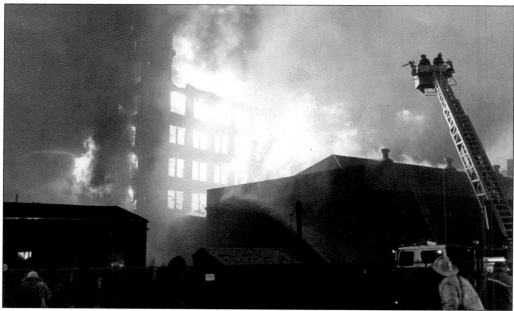

Access to the fire buildings by fire apparatus was difficult due to the possibility of collapse and the intense heat. Apparatus was located away from the buildings as is evident in the above photograph. Cambridge's aerial platform, after relocating, is shown reaching over Sterling Machine Company to begin operating on the Benson Shoe Building, now almost completely involved in fire. (Courtesy Bill Noonan.)

This is another view of Cambridge aerial platform No. 1 in action at the Benson Shoe Building, again this is the rear of the building on Farrar Street. Cambridge supplied pieces of equipment over the course of the fire. (Courtesy Bill Noonan.)

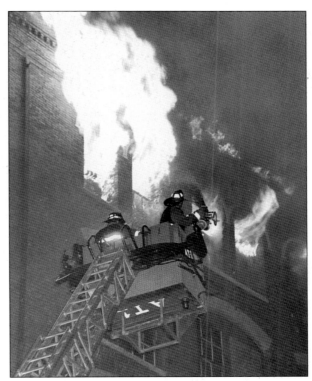

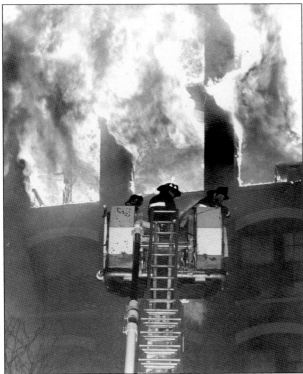

Many of the buildings that burned were constructed at the beginning of the 20th century. The walls were brick, but the floors were floor-joists and the stairs were wood. They were occupied as shoe-related businesses and over the years were exposed to many flammable chemicals and adhesives. This heavy fire load is evident in the volume of fire that the members of Cambridge's aerial platform confronted at the Benson Shoe Building. (Courtesy Bill Noonan.)

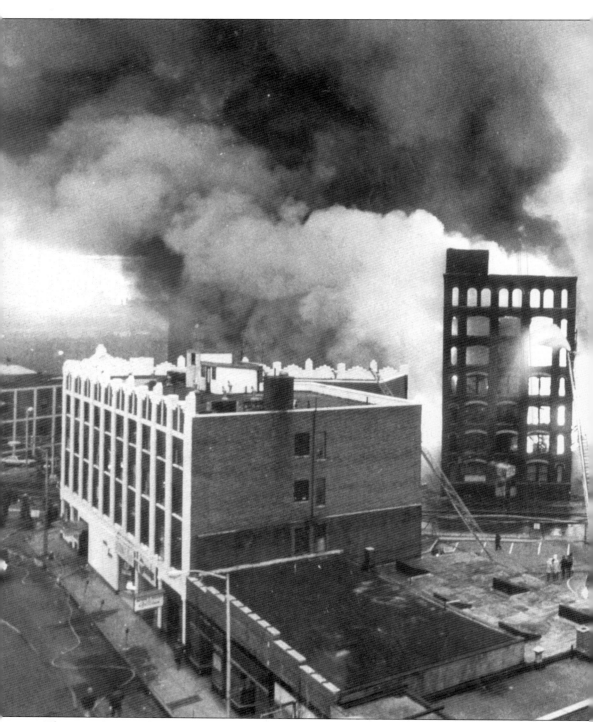

This aerial view shows firefighters working on the eight-story Benson Shoe Building and protecting the five-story Glenmere-Hub Die Building. The far right side of the picture shows the intersection of Broad and Washington Streets with heavy smoke coming from multiple buildings

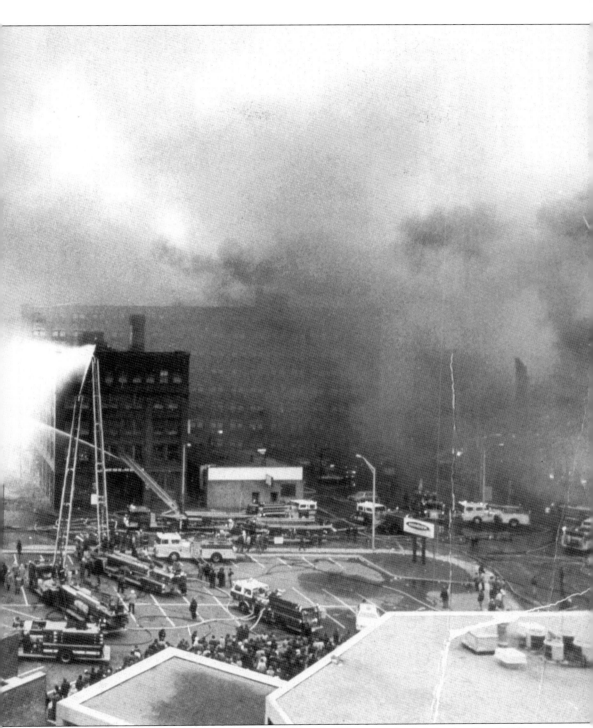

that had burned earlier in the morning. The large building on the left is the Hotel Edison, located at the corner of Broad and Exchange Streets. (Courtesy John Tlumacki.)

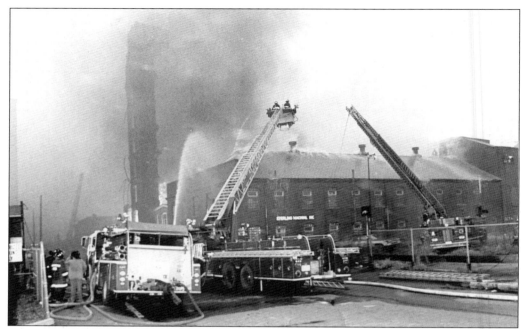

Apparatus from over 80 communities assisted the Lynn Fire Department in battling this large fire. The tall remains on the left are the rear wall of the Benson Shoe Building. (Courtesy Bill Noonan.)

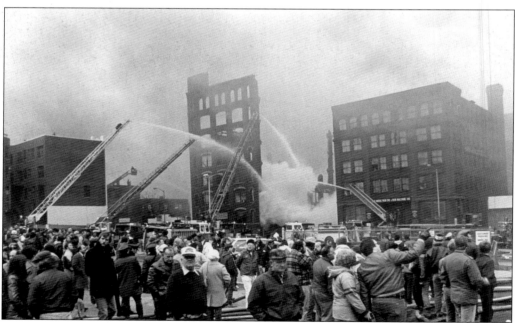

A large number of spectators gathered around the area to view the fire. Fire and heat traveled over and around the five-story Glenmere-Hub Die Building at 210 Broad Street, shown at the right of this photograph, and ignited the eight-floor Benson Shoe Building at 190 Broad Street. (Courtesy Bill Noonan.)

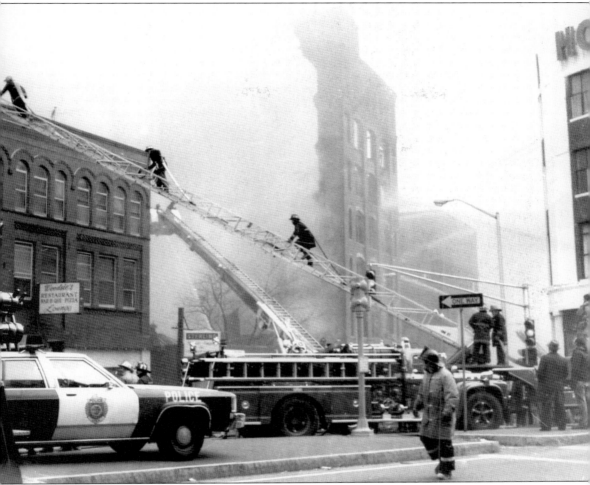

The fire extended up Broad Street as far north as the Sterling Machine Building. Firefighters are shown advancing a hand line over an area ladder to the roof of Sterling Machine, which suffered moderate damage. The front wall of the Benson Shoe Building is all that remains. (Courtesy Conway collection.)

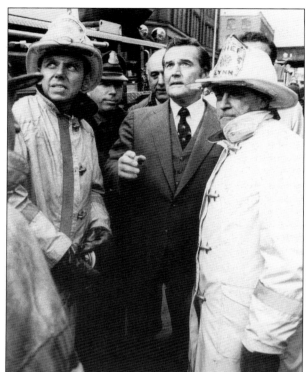

Gov. Edward King was in Lynn early Saturday morning and offered the state's assistance to the city. He arrived in a state police helicopter, which was later used by the chief of department and the deputy chief to observe the fire area from above. This photograph was taken on Washington Street and shows, from left to right, deputy chief Bill Conway, Governor King, and chief of department Joseph E. Scanlon Jr. looking at the Vamp Building burning. (Courtesy Steven Nowicki.)

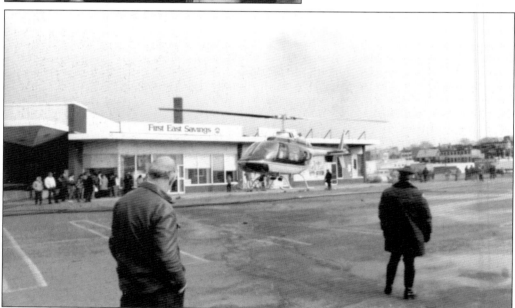

A state police helicopter carrying the governor, chief of department, deputy chief, and a state police pilot departs a parking lot in the rear of the fire area. The helicopter is in front of the First East Savings Bank, which was to the right of the old Stop and Shop food market. At the time of the fire, it was being used as the Roosevelt Flea Market, which was damaged when the rear wall of the Marshall's Wharf Building collapsed.

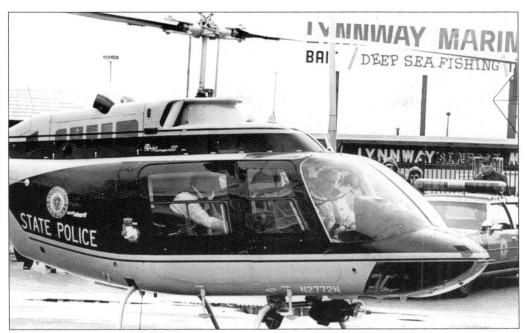

Chief of department Joseph E. Scanlon Jr. made two aerial tours of the fire area to obtain necessary information to combat the conflagration. Chief Scanlon is in the front with Governor King in the rear. (Courtesy Conway collection; photograph by Jim Daigle.)

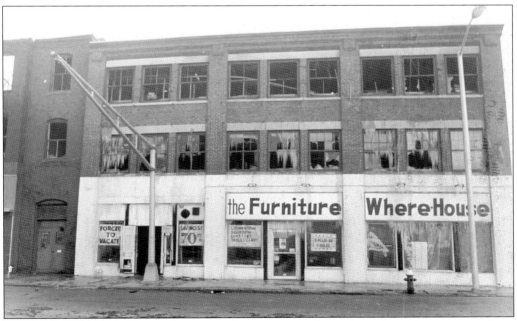

The Furniture Where House three-story furniture store located on Broad Street across from the Vamp Building was totally destroyed. The sign in the left-hand window stating "Forced to Vacate" was there prior to the fire. To the left of this building was a large three-story, similarly constructed, shoe and athletic supply store. (Courtesy Conway collection.)

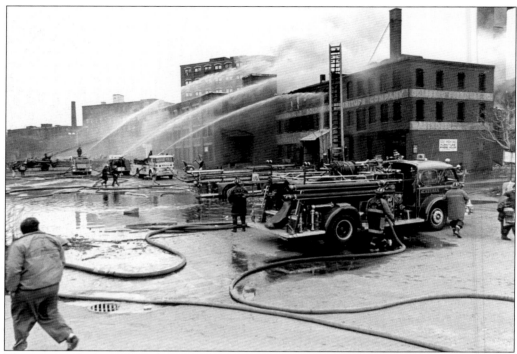

This view is looking from the Lynnway with the Furniture Where House in the center and Goldberg's Furniture Warehouse to the right. The tall tower on the extreme upper right is all that is left of an elevator shaft from the Marshall's Wharf Building. The vacant lot in the left center was the location of the old Broad Street Fire Station that had been torn down in the early 1970s. (Courtesy Bill Noonan.)

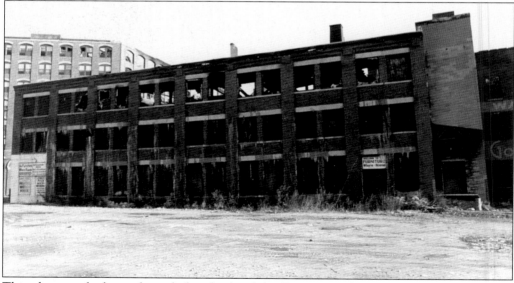

This photograph shows the right-hand side of the Furniture Where House. To the right was another large three-story furniture warehouse, Goldberg's. This was the furthest south the fire extended. (Courtesy Conway collection; photograph by Bill Noonan.)

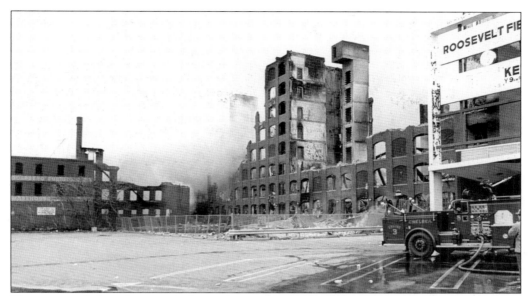

The center of this photograph shows the remains of the Marshall's Wharf Building, which was in the process of being converted from a shoe factory to industrial condominiums. It was nearing completion and was about 60 percent occupied. The two buildings on the left were Goldberg's Furniture Warehouse and Elm Shank and Heel Company, which were located behind the Furniture Where House and the Musinsky shoe store. (Courtesy Conway collection; photograph by Bill Noonan.)

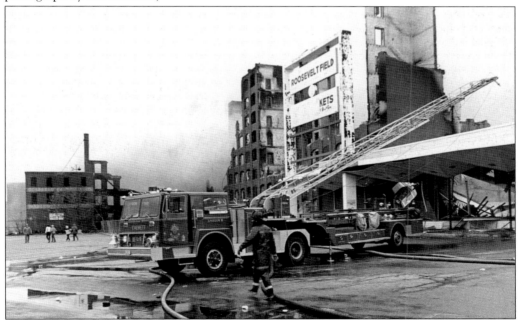

An Everett ladder truck is located in front of the old flaw market building. When part of the rear wall of the Marshall's Wharf building collapsed, it fell through the roof of the flea market building; the large opening in the roof is visible in this photograph. On the left are the remains of Goldberg's Furniture Warehouse. (Courtesy Bill Noonan.)

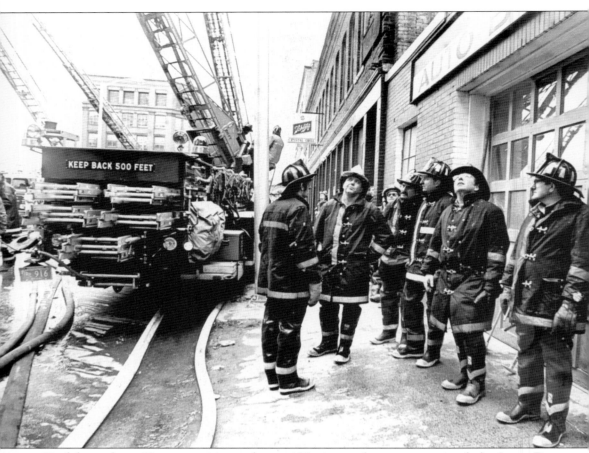

Firefighters from 80 communities and over 120 pieces of apparatus assisted the Lynn Fire Department in combating this fire. During the height of the fire, 40 heavy streams from deck guns and wagon guns, 25 ladder pipes including two aerial platforms, three squirt booms, and numerous hand lines were used. This view shows out-of-town firefighters awaiting orders while four aerial ladders are in operation on Washington Street in the rear of the Vamp Building. (Courtesy Conway collection; photograph by Jim Daigle.)

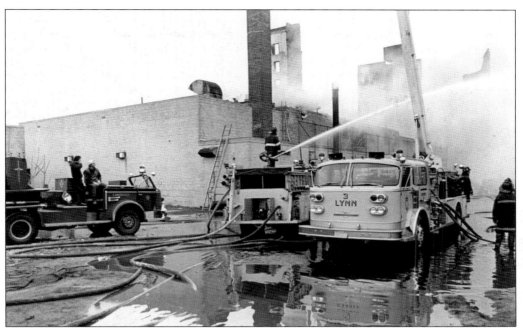

This is Lynn's engine No. 3, a squirt, located in the rear of fire building. This is the same area in which the crane that was dismantling the Hutchinson Wharf Building was located. In the background, the remains of the buildings fronted on Broad Street are visible. The large windowless building in the rear was Stop and Shop supermarket and later the flea market. (Courtesy Bill Noonan.)

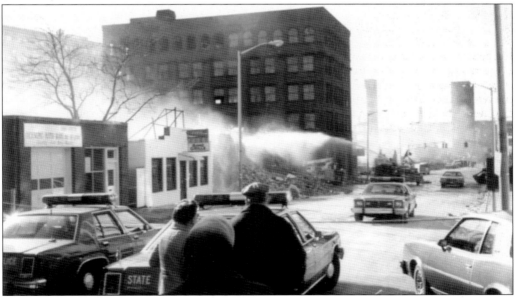

The pile of rubble in the center of the photograph is all that remains of the Benson Shoe Building. The main body of the fire traveled from the center of this image, over the five-story building, setting Benson Shoe ablaze. The Benson building then collapsed into the restaurant and auto body shop shown at the left center. (Courtesy Conway collection.)

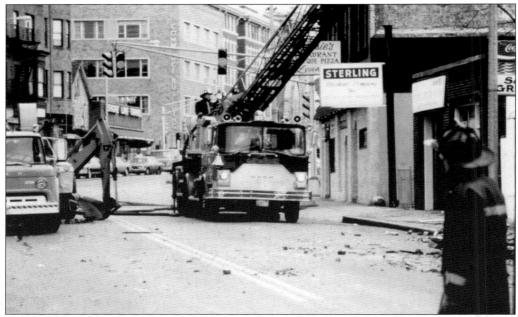

Lynn's ladder No. 1 is shown working on Broad Street in front of Sterling Machine Company. It had originally been set up in front of the Hutchinson Wharf Building and was relocated many times during the fire. The front of the truck is burnt, and the plastic lens covers have been melted. (Courtesy Conway collection.)

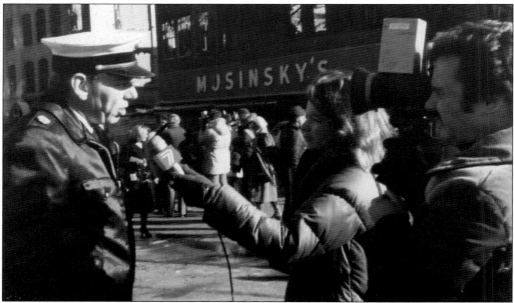

The fire occurred Saturday morning of Thanksgiving weekend and made headlines in all the major national papers. Local television stations had live coverage on the scene for many days. Shown above is channel 7 news reporter Susan Burke interviewing deputy chief Bill Conway while in the background other media outlets are interviewing U.S. senator Edward Kennedy and chief of department Joseph Scanlon Jr. (Courtesy Conway collection.)

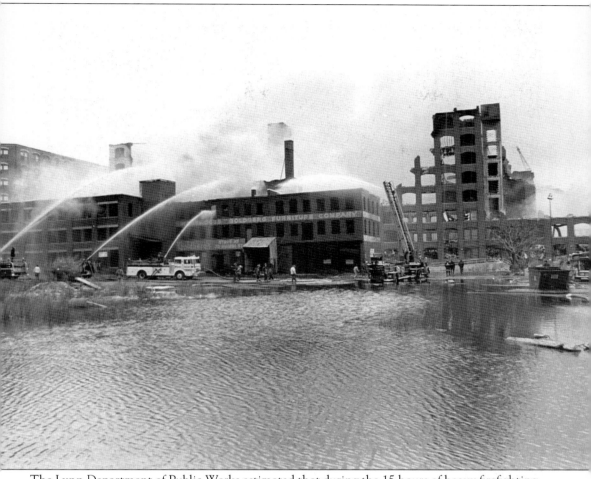

The Lynn Department of Public Works estimated that during the 15 hours of heavy firefighting, over 50 million gallons of city water was used. This amount included what was used for firefighting operations and water that was lost due to broken supply lines from collapsed structures but does not include the water drafted by four engines from Lynn Harbor. Some of this water is shown in a parking lot behind some of the fire buildings. (Photograph by Bill Noonan.)

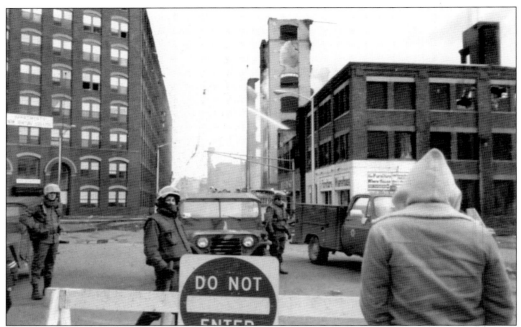

The U.S. National Guard arrived early Sunday morning to help the Lynn police keep spectators away from the fire area. They are shown here in Liberty Square at Broad Street. The Vamp Building is on the left; to the right are all the burned-out buildings. The first tower on the right is the remaining stairway of the Marshall's Wharf Building, and the second tower is what was left of the Hutchinson's Wharf Building. (Courtesy Conway collection.)

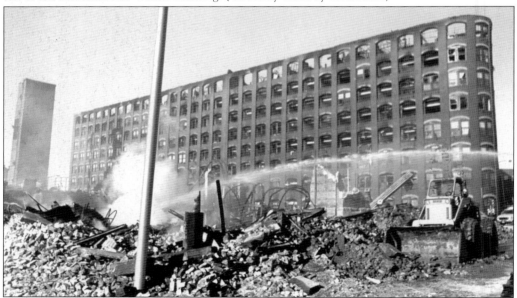

This photograph, taken on Sunday morning November 29, 1981, shows the badly damaged Vamp Building from the Broad Street side. Having recently been converted to housing, the Vamp Building had only been occupied since the previous Monday. All residents were safely evacuated. (Courtesy Conway collection.)

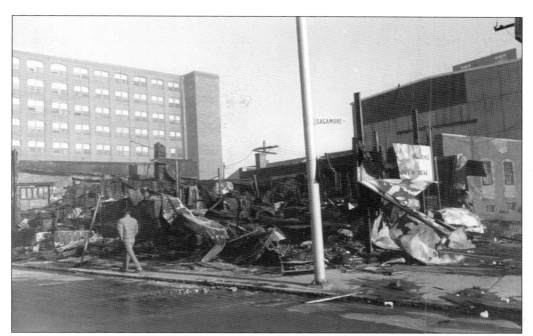

Above are the remains of the Potter's Pantry building, a one-story wood-joist construction used as a catering building at the corner of Washington and Sagamore Streets, across from some of the main fire buildings. The eight-story building in the background was another former shoe factory recently converted to housing. It received only minor damage. (Courtesy Conway collection.)

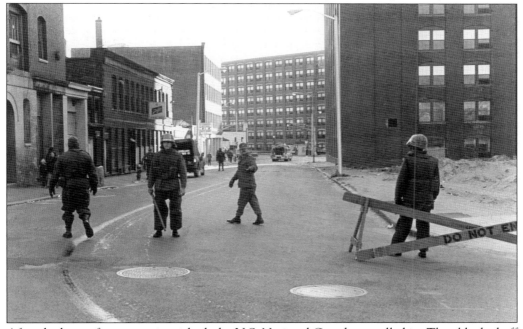

After the heavy fire was extinguished, the U.S. National Guard was called in. They blocked off all the streets leading to the fire area. They are shown in the above photograph on Washington Street at Union Street, just a few yards from Central Square. (Courtesy Kathryn Kirk.)

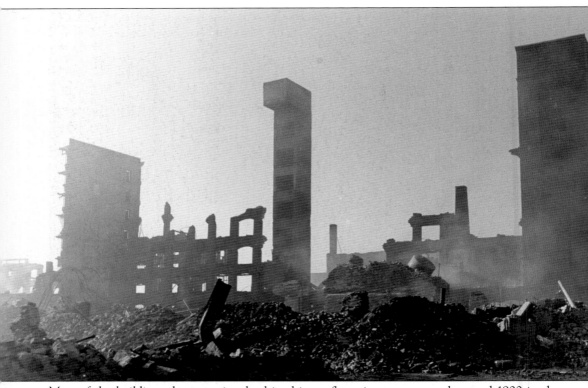

Most of the buildings that were involved in this conflagration were erected around 1900 in the area that was destroyed in the First Great Lynn Fire of 1889. They were of brick and wood-joist construction, separated from each other by narrow alleys, and ranged between five and eight stories in height. Many of the self-enclosed stairwells survived when the buildings around them collapsed.

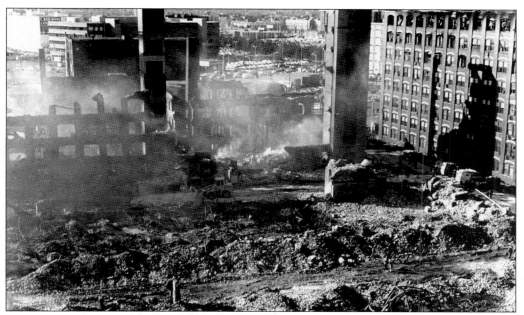

Once the heavy fire was extinguished, the so-called "hot spots" had to be put out. Before this could be accomplished, any hazards such as still-standing damaged buildings or parts of damaged buildings had to be razed. A road was also made through the rubble. The area above the clearing is the remains of the Hutchinson's Wharf Building. (Courtesy Kathryn Kirk.)

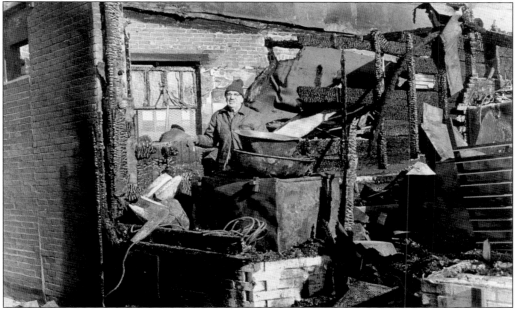

A total of 27 structures were involved in this fire, with the destruction and damage ranging from total to slight. The dollar damage was set at somewhere between $70 and $80 million. In the photograph above, this business was totally destroyed; the owner is looking through the rubble hoping to find anything of value. This is likely the Elm Shank and Heel Company located at 25 Marshall's Wharf. (Courtesy Kathryn Kirk.)

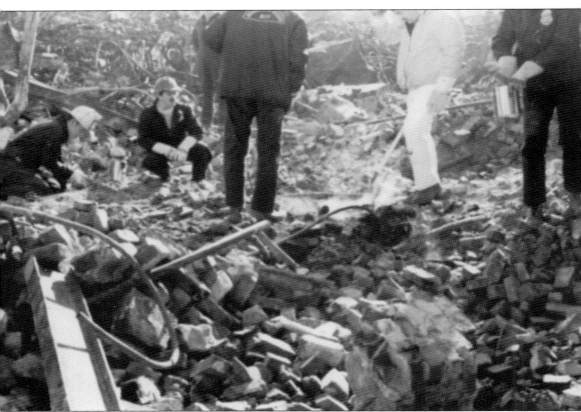

Shortly after the fire was extinguished, a task force was formed to investigate the cause. Included in the force were members of the Lynn Fire and Police Departments; the state police; the state fire marshall's office; and the Alcohol, Tobacco and Firearms Office. It was determined that the fire was set. One person was arrested for perjury during the investigation. The prosecutor in the U.S. District Court case was U.S. attorney William Weld, later the governor of Massachusetts. Above the task force searches the debris of the Hutchinson Wharf Building.

Five

AFTERMATH

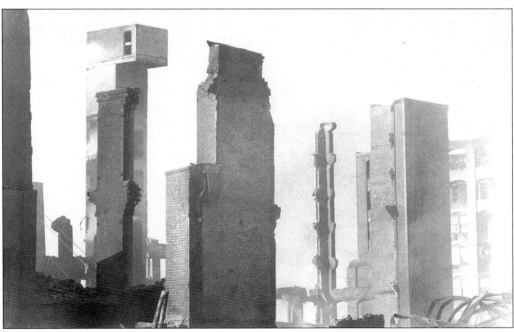

For days following the 1981 fire, the city resembled nothing so much as a war zone, the ruins of the burned downtown area giving the impression of the bombed-out buildings of World War II Europe. The most disheartening aspect of the fire for many Lynn residents was that it snatched away plans for renewal and revitalization of the area.

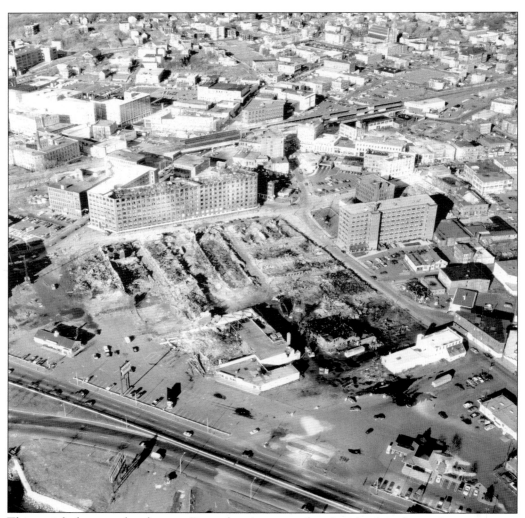

This aerial photograph taken on December 4, two weeks after the fire, shows the gaping scar that was left after the rubble was cleared. Directly across Broad Street from the burned-out lots is the Vamp Building with its damaged top floors clearly visible. The Harbor Loft apartments are to the right, across Washington Street. Directly in front of that building is the old Tapley Building, a 19th-century shoe factory that survived the 1981 fire only to burn in 2000.

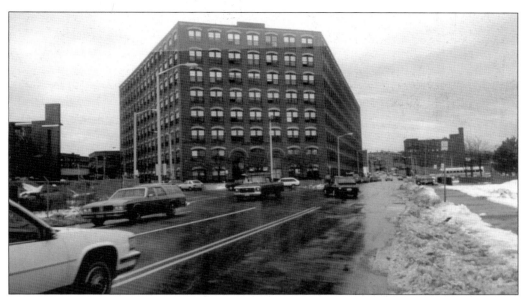

The Vamp Building was completely restored in the months that followed and continues to be used as a residential apartment house.

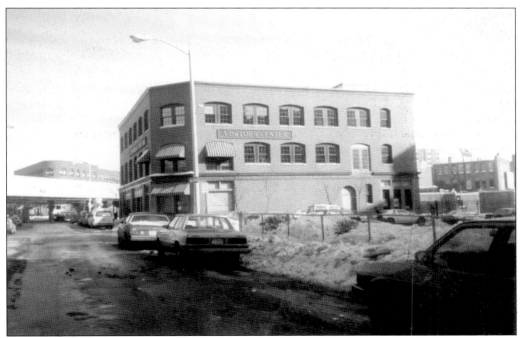

At the outside edge of the fire district, the Lynn Heritage State Park Visitors Center opened in 1988 as the first step in the revitalization of the area.

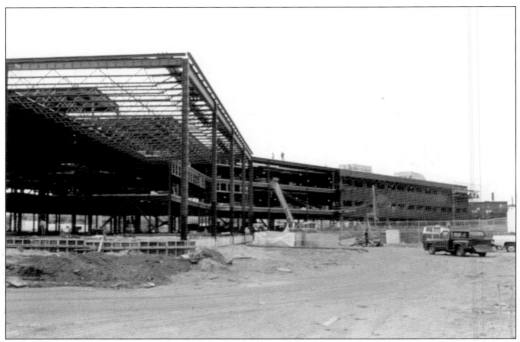

Northshore Community College had already drawn up plans for a presence in Lynn, the vacancies left by the fire made possible a more ambitious campus. Groundbreaking for the Thomas Magee Building took place in 1985.

For more than 20 years the Lynn campus has offered a variety of courses and opportunities to Lynn residents and added a lively presence to the downtown.

Today little evidence remains of the conflagration of 1981. Businesses have rebuilt, new ones have moved in, and although the fire delayed it for many years, downtown Lynn's revival now seems well underway.

ACROSS AMERICA, PEOPLE ARE DISCOVERING SOMETHING WONDERFUL. *THEIR HERITAGE.*

Arcadia Publishing is the leading local history publisher in the United States. With more than 3,000 titles in print and hundreds of new titles released every year, Arcadia has extensive specialized experience chronicling the history of communities and celebrating America's hidden stories, bringing to life the people, places, and events from the past. To discover the history of other communities across the nation, please visit:

www.arcadiapublishing.com

Customized search tools allow you to find regional history books about the town where you grew up, the cities where your friends and family live, the town where your parents met, or even that retirement spot you've been dreaming about.